A smart eye in China

By R Thomas Berner

托马斯·伯纳

A smart eye in China

R Thomas Berner

Copyright 2006 R Thomas Berner. All rights reserved. Reproduction, electronic storage, distribution or resale in part or in whole is prohibited without written consent. For details or further information regarding this book or its contents, contact the author: bx2@psu.edu.

I have been very lucky to have taught in China twice and visited five other times and the reason I've more than gladly returned is the people. The Chinese are welcoming and non-judgmental people. They accept you as you are; they ignore your faults. I've been in China twice when our governments were clashing and the people of China greeted me warmly even when other Chinese were trashing our embassy in Beijing or dismantling one of our planes on Hainan Island.

Over the years I've developed several good relationships. Chinese have visited me in the United States and I have had several happy reunions with old friends in China. My affection grows deeper with each visit.

After my first visit, several people suggested that I write a book about China. I never felt I knew enough about China to write a book, but after seven visits and 10,000 photographs I am ready to produce a book of my photographs.

I've tried to avoid cliché photographs. I have seemingly millions of photos of people riding bicycles and (fewer) of people watching television in a department store. You've seen those photos in newspapers.

I wanted, instead, to present original images that show my affection for the people and their culture.

My calligraphy teacher, who always looked at my recent photographs of China on my computer after each calligraphy lesson, told me that I had "smart eyes," hence the book's title.

I hope you enjoy the images.

Suzhou 1994

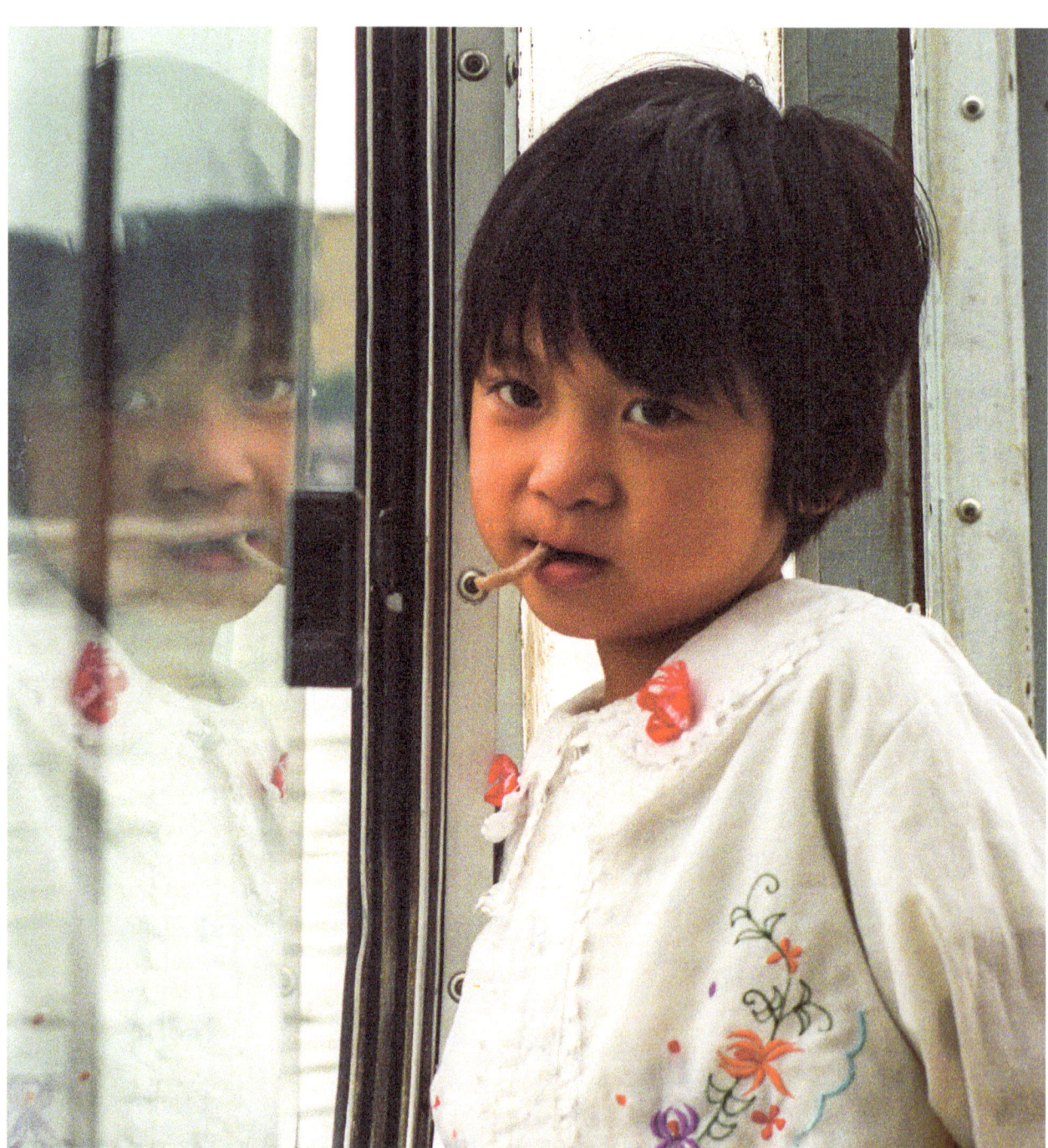

Dalian 2005

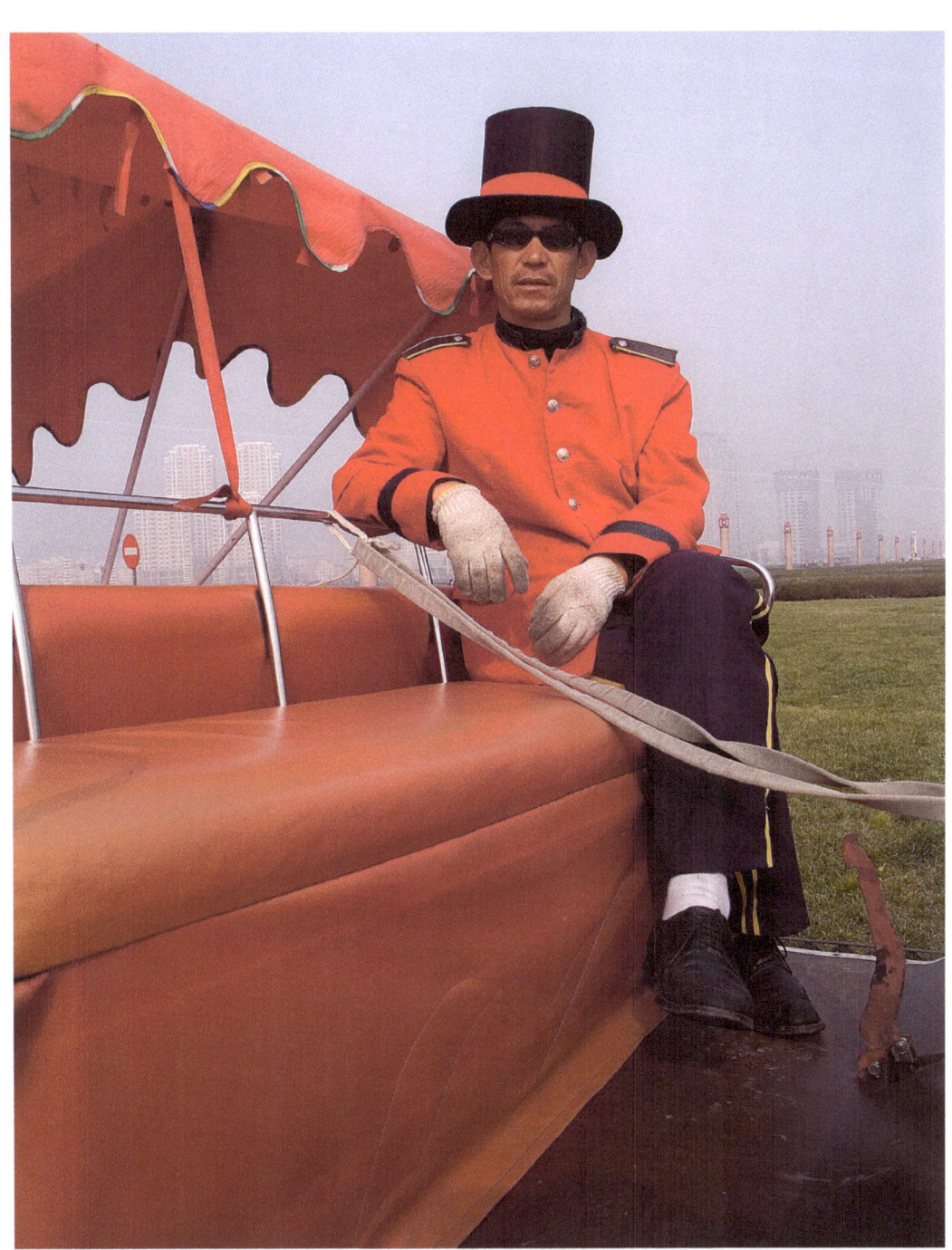

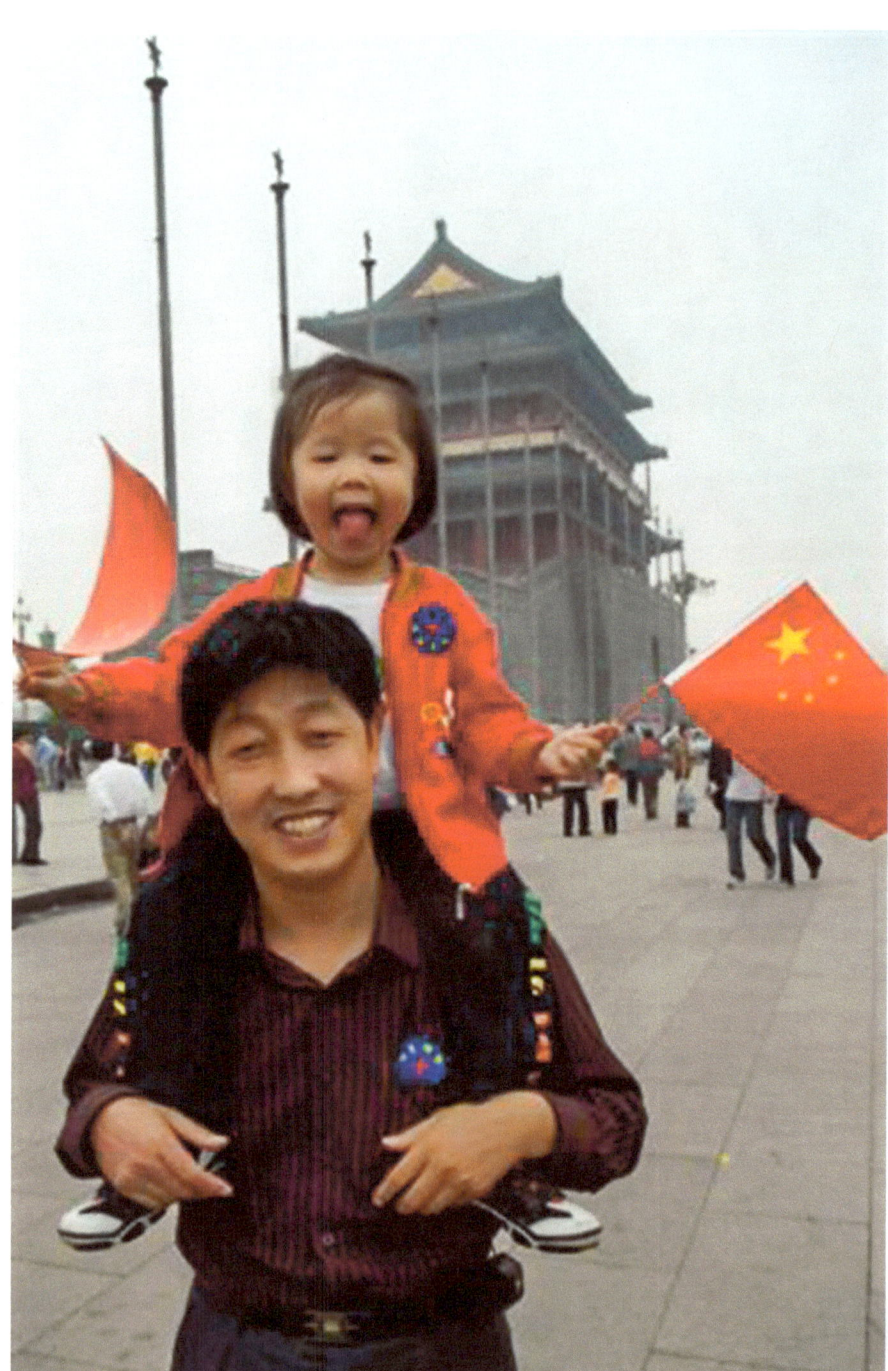

Beijing 2005

Beijing 2005

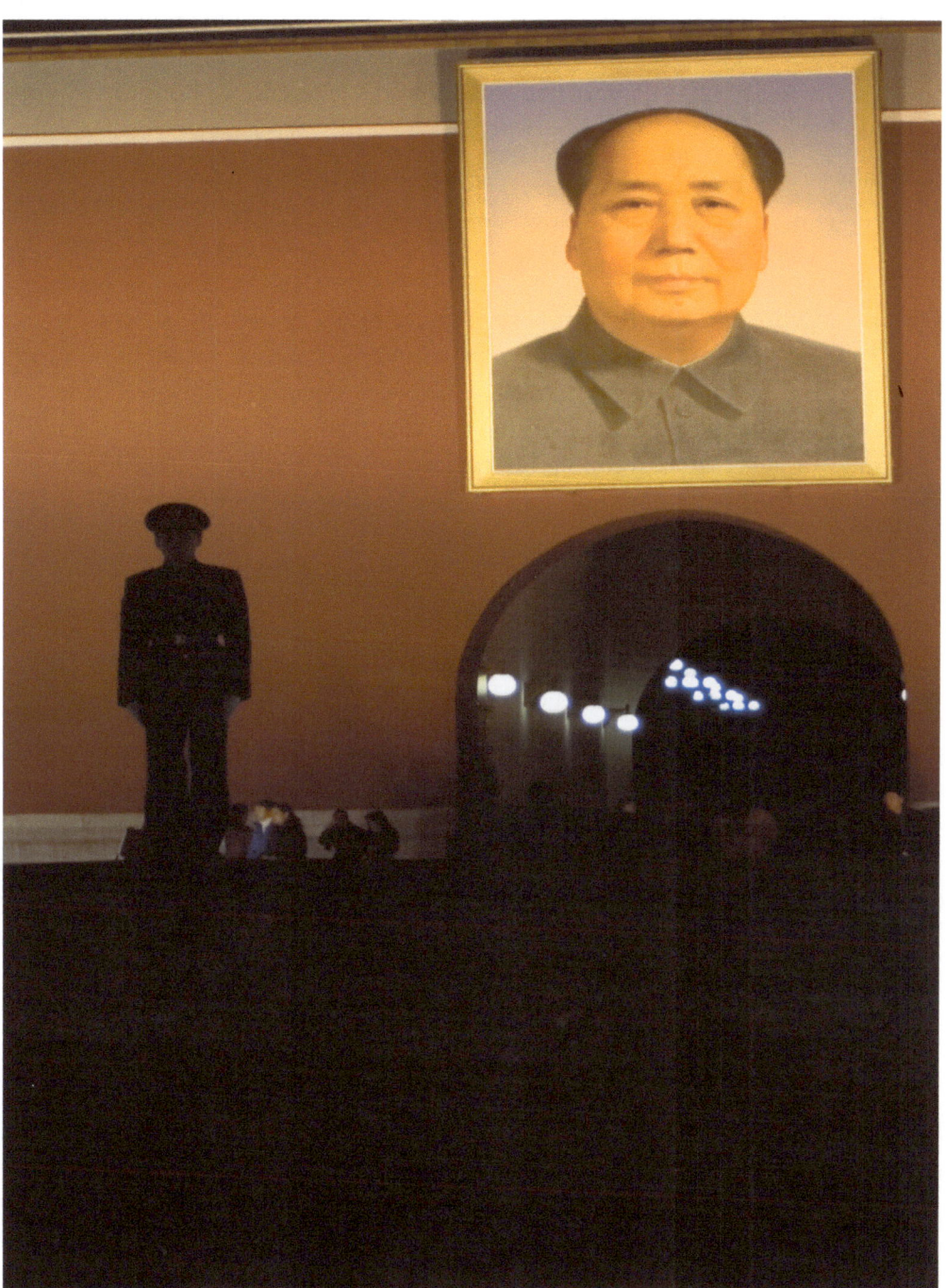

I n my first two visits to China, I would inevitably stumble upon a wedding reception, always at a restaurant. Since it is good luck to have a stranger appear at your reception, the bride and groom welcomed me and allowed me to take a photo or two. The receptions were subdued and the bride always wore red.

Why not white?

Because white is the color associated with death.

Not anymore.

On my last visit to China I saw more and more brides dressed in rather elaborate white gowns. Usually, I encountered them in a pleasant setting having their wedding photos taken. I later learned that it had become the custom in China to rent the wedding clothing and have a professional photographer take pictures. (In Guangzhou, the photo crew traveled in a mini-bus with the words "Famous Wedding Photographer"—in English—on the sides.) Usually, the bride wore white. The actual wedding ceremony was held at another time and was usually a modest affair.

Tradition dies hard. I did come upon one couple on a beach in Dalian. The bride was wearing red. The couple was quite willing to pose for me but the professional photographer and videographer made it clear they were not happy that I was taking photos. They tolerated me for two minutes then moved up the beach.

Not all wedding receptions are subdued. Once, while on a morning stroll in Jixi in Heilongjiang Province, I happened upon a wedding reception in a hotel. I waited for the bride and groom to arrive. They did—in a caravan of rented Mercedes Benzes to the ear-damaging sound of exploding firecrackers. On National Day (October 1) in Beijing I witnessed from my taxi a bride and groom riding in the back of a convertible while a videographer recorded them from a car in front of them. (In China, getting married on a fortuitous holiday brings good luck. In a twist, with divorce on the rise, one newspaper suggested people get divorced on the eve of a holiday—for luck.)

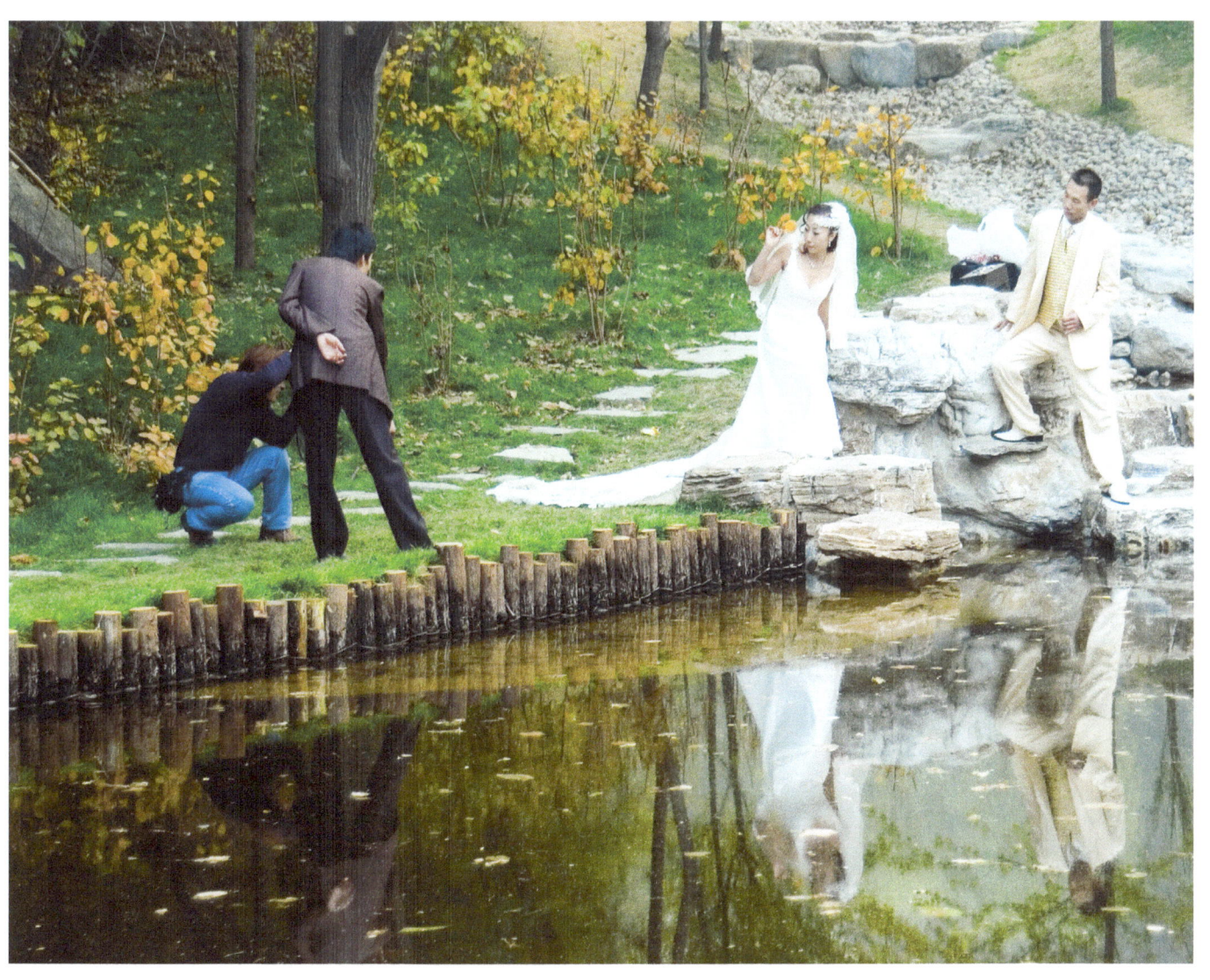

Beijing 2005

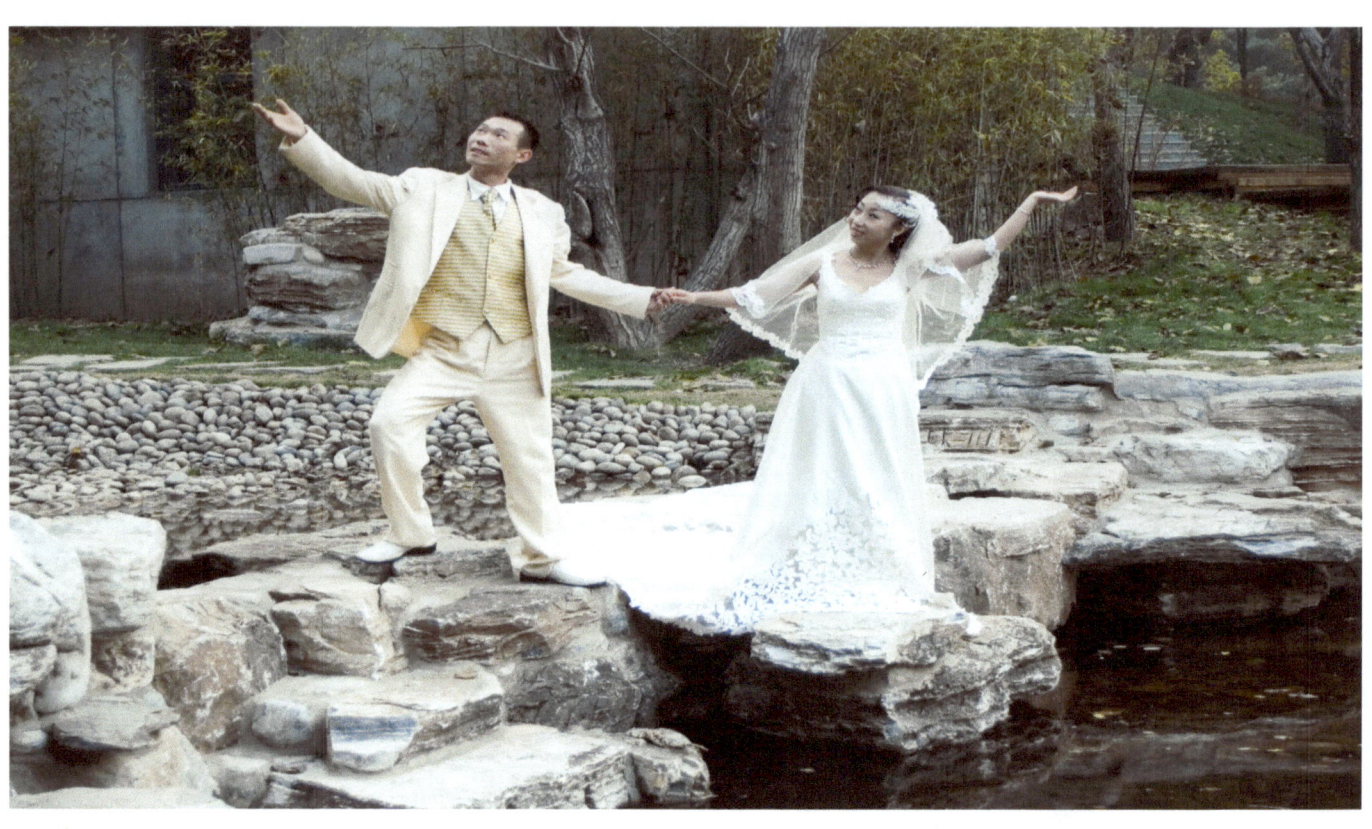

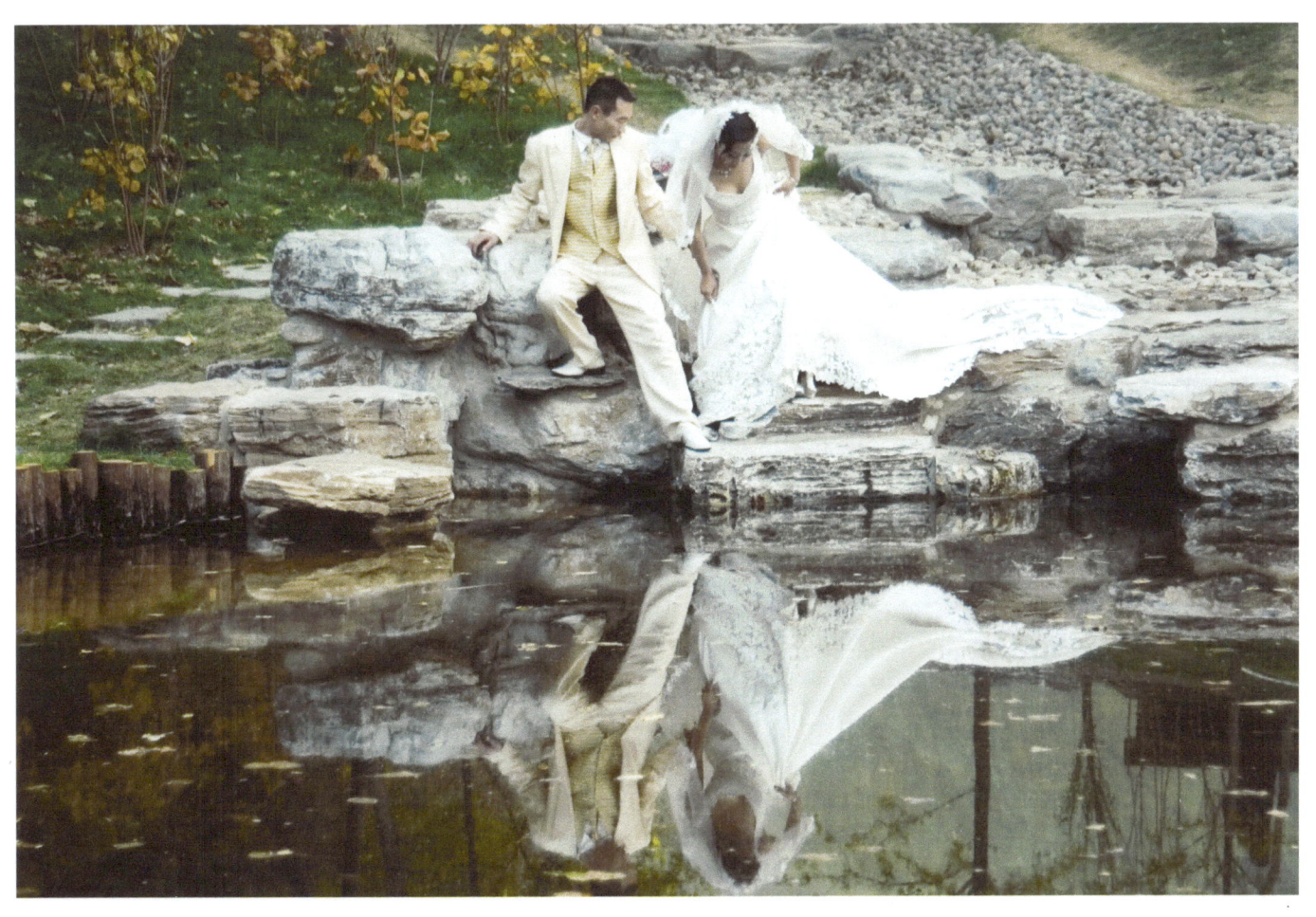

While freshmen at many universities in the world report to campus before classes start as part of an orientation—how to register for courses, how to find your dormitory and so on—freshmen in Chinese universities also get military training varying from two to four weeks and either on campus or at an Army facility.

Mandatory military training for all freshmen—men and women—started after the Tiananmen Square student protests of 1989 in which an unknown number of protestors were killed by soldiers. According to one Chinese adult I spoke to, modern students need to learn more about their country and he thought the military training was a good idea. In other words, their nationalism was in doubt. He pointed out that the modern Chinese student is spoiled (most are only children and are doted on by grandparents and parents). One of my former (1994) students wondered what the (2005) students would think of the training in the age of McDonald's and the Internet.

No matter what they thought, students at Tsinghua University would arise early and form up in uniforms outside their barracks, then march off to various training sites. When they "graduated" from military training, they demonstrated on a regimental parade ground what they had learned. One company, for example, showed off its martial arts routine. They all marched in review, some straighter than others. (A young girl imitated them on the sidelines.)

Mixed in with the military drills was friendly collegiate competition. Each company produced a poster boasting of their stalwartness and one group said that "The sky is the limit. DPIM will make it." They were the students from the Department of Precision Instruments and Mechanology and their poster also proclaimed "Diligence, Perspective, Innovation Make Us Outstanding!"

Beijing 2005

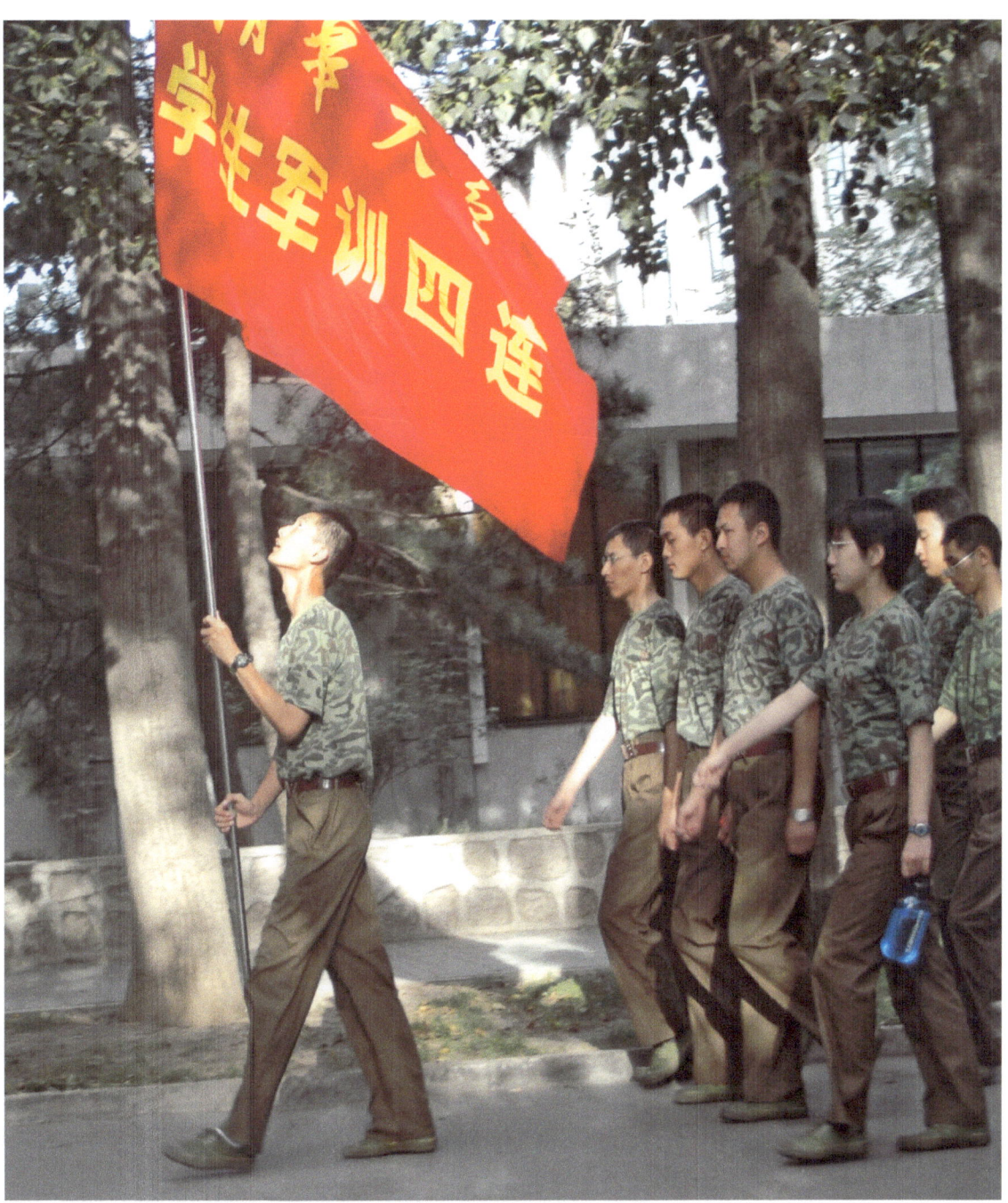

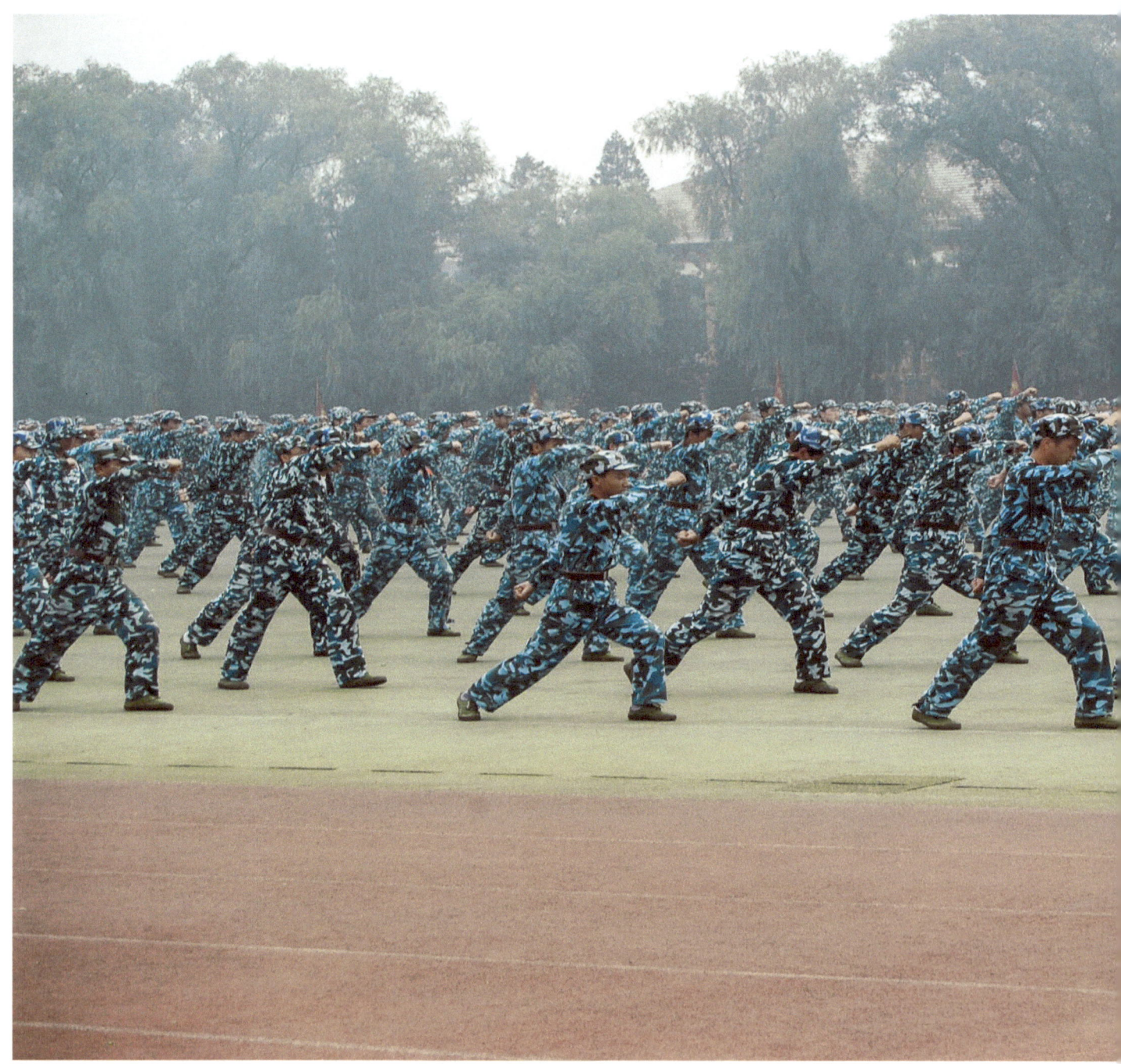

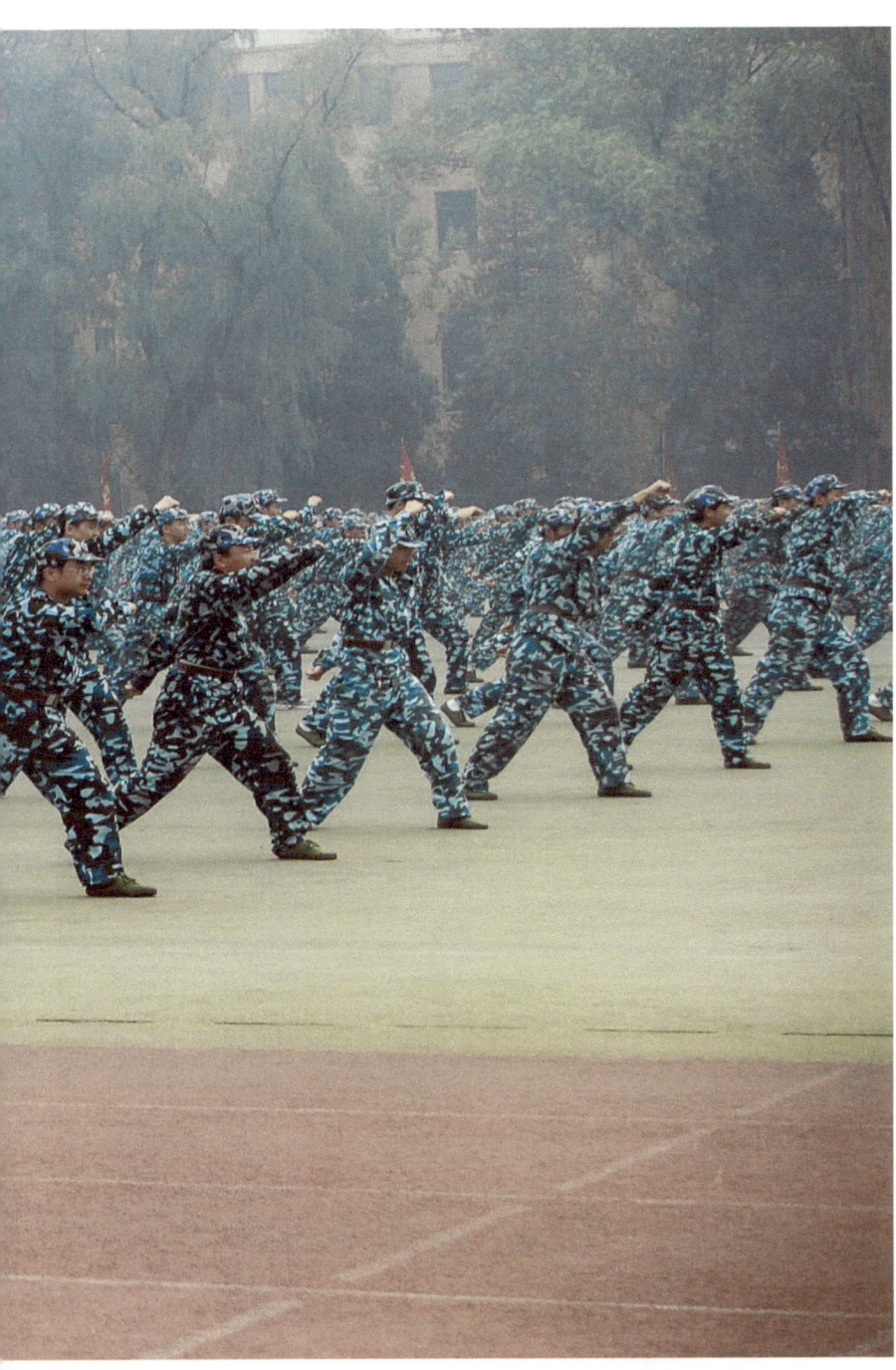

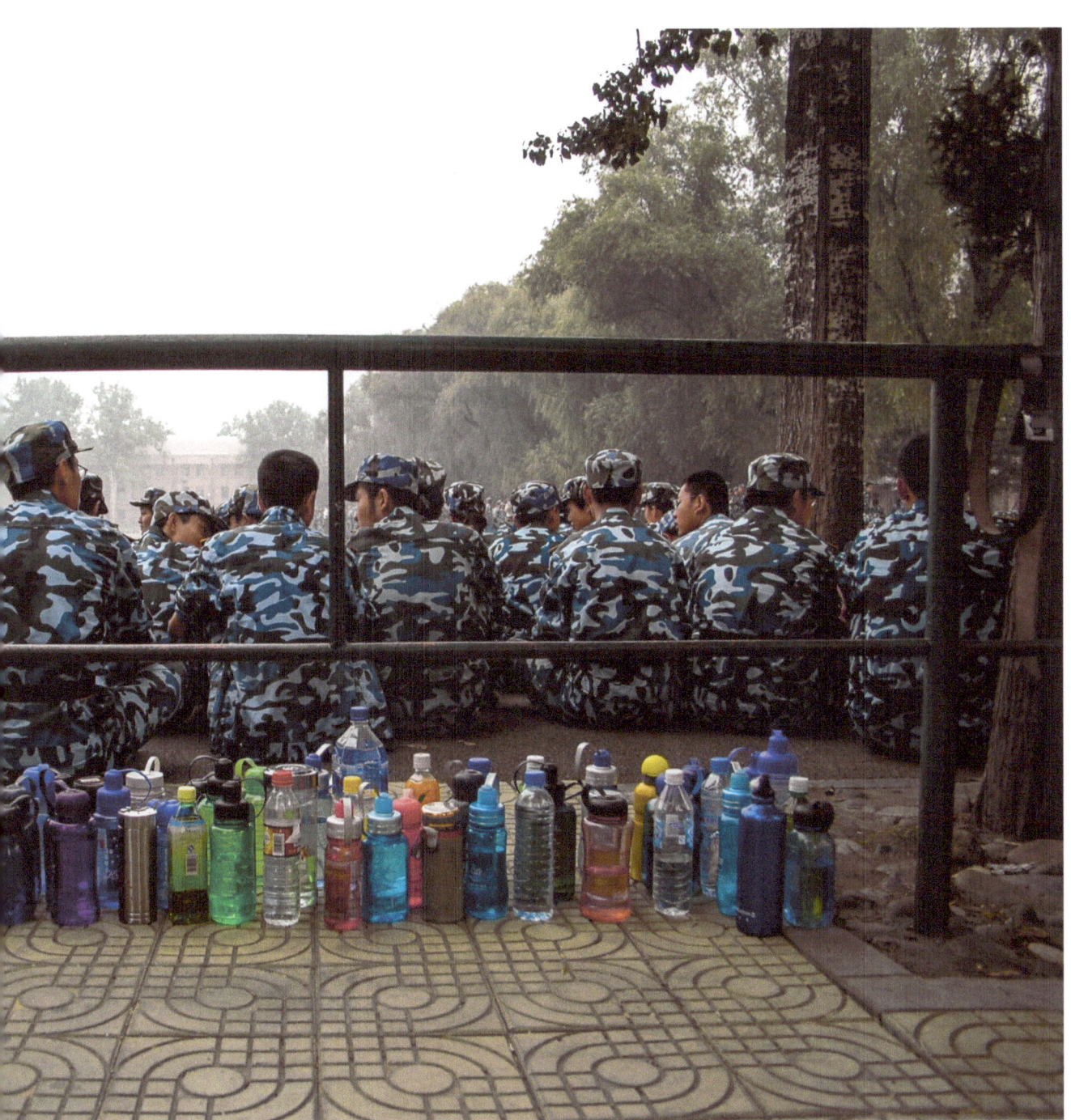

Who can resist a panda? The white face with the black accent around the eyes. The eyes just looking right at you. You don't even need to know that the panda (known as the giant panda) is endangered and that approximately only 1500 of them exist. They are indigenous to China, but the Chinese government has given, sometimes for a fee, panda couples to zoos in the west.

Couples!

Sex?

No. Sorry.

Pandas are not very amorous and the few interactions of couples in captivity have been well documented in the news media. The birth of a cub, as was the case at the Washington Zoo in 2005, was front page news. What war? What economic problems? Baby panda!

In fact, 2005 was a good year for panda births in China. Thanks to artificial insemination, a record 25 pandas were born in that country, with 21 surviving.

At the Beijing Zoo, tourists can see more than one couple, and if one panda is shy and retiring, there's always the possibility that another one might make eye contact and melt your heart.

Pandas spend most of their time eating or sleeping. Bamboo is their main food supply and their daily intake is measured in pounds, usually upwards of 30 at the minimum.

So when visitors to the Beijing Zoo find a panda chomping on bamboo shoots, it is a photo opportunity like no other, especially if the tourists encountered sleeping or nonchalant pandas inside the huge panda center. Break out those digital cameras, those point and shoots, those cell phone cameras. Don't miss the opportunity to photograph a panda doing something. The tourists can be almost as interesting as the pandas.

By the way, there's an additional charge to visit the pandas, but it's worth it.

Beijing 1994

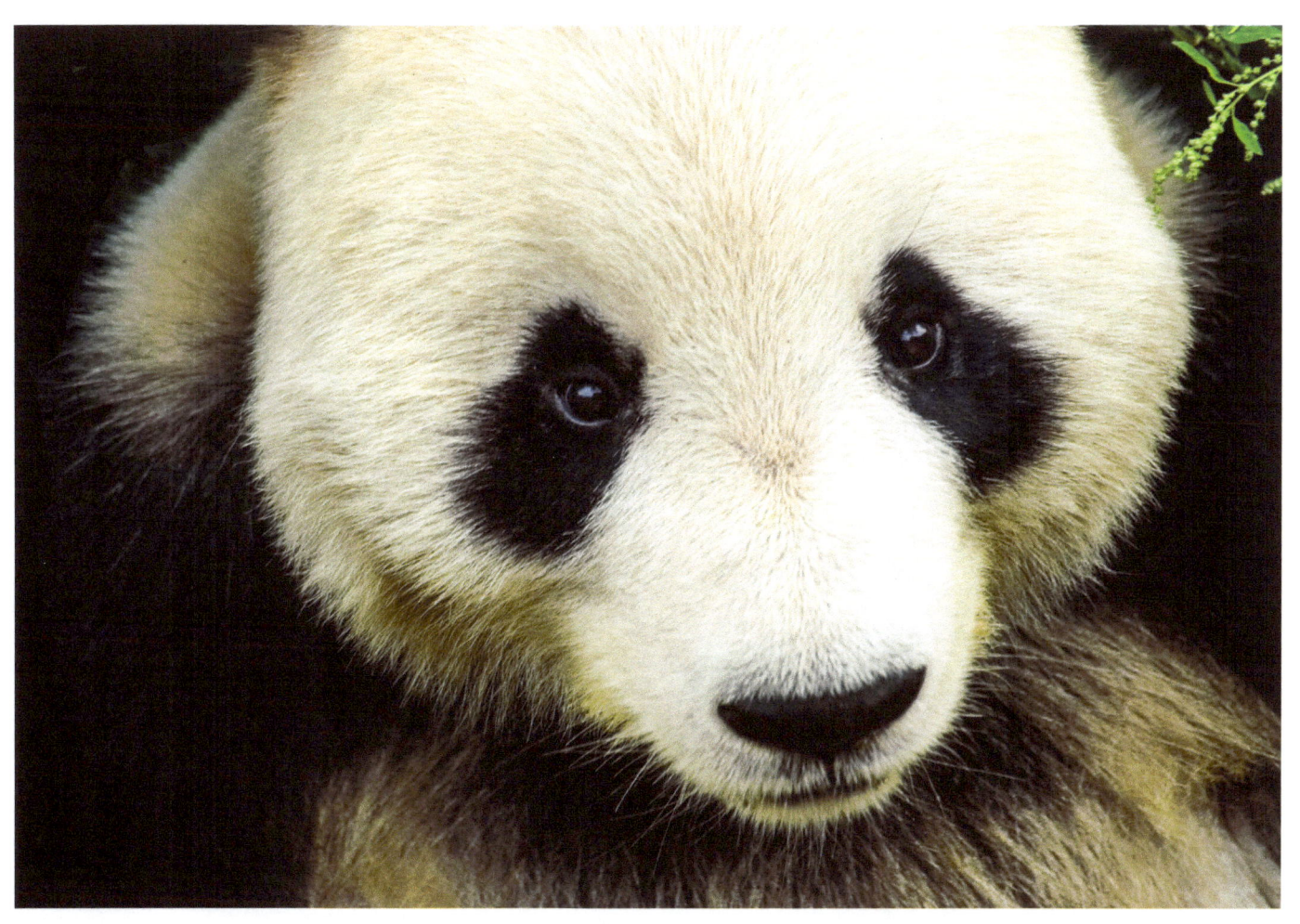

Beijing 2005

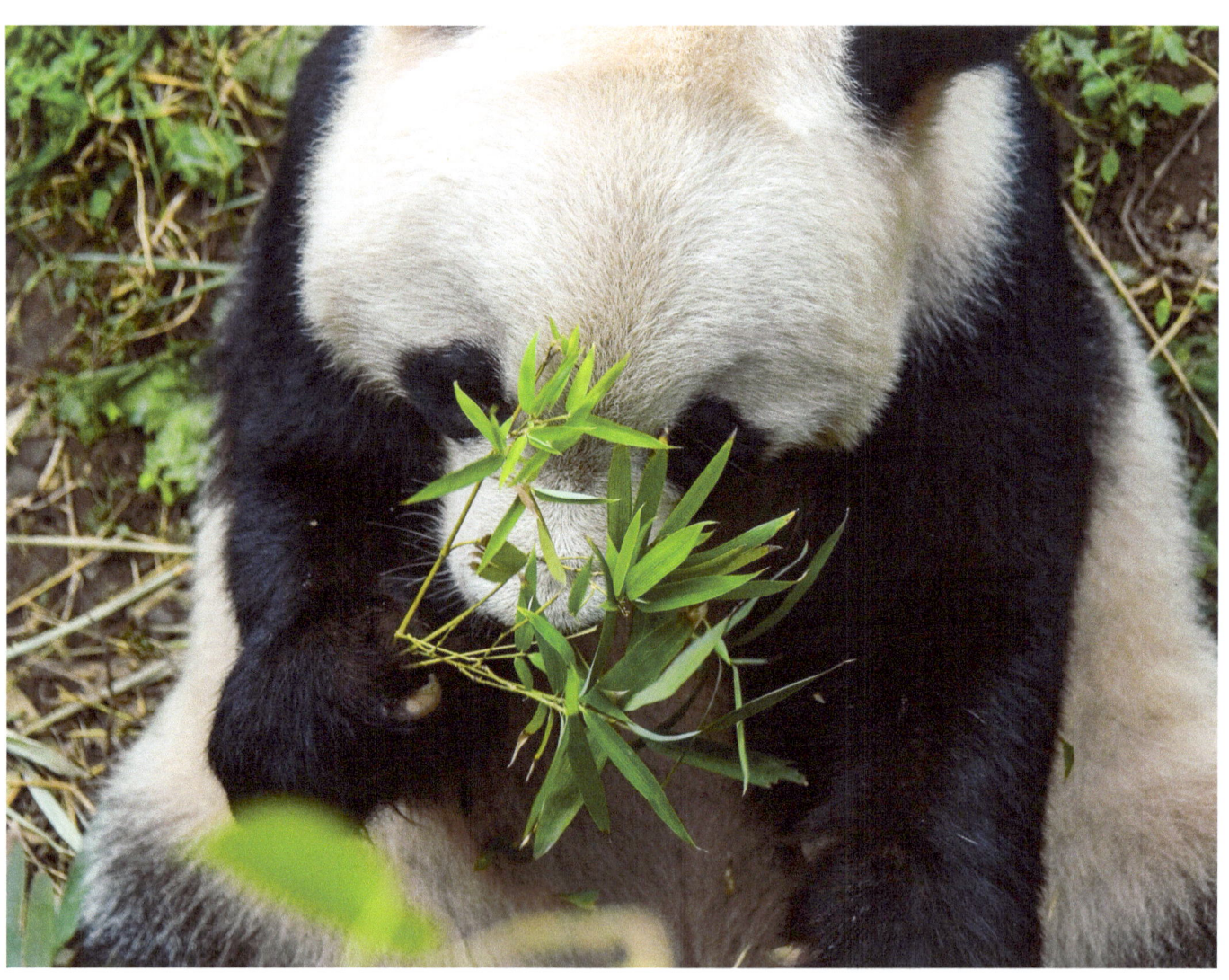

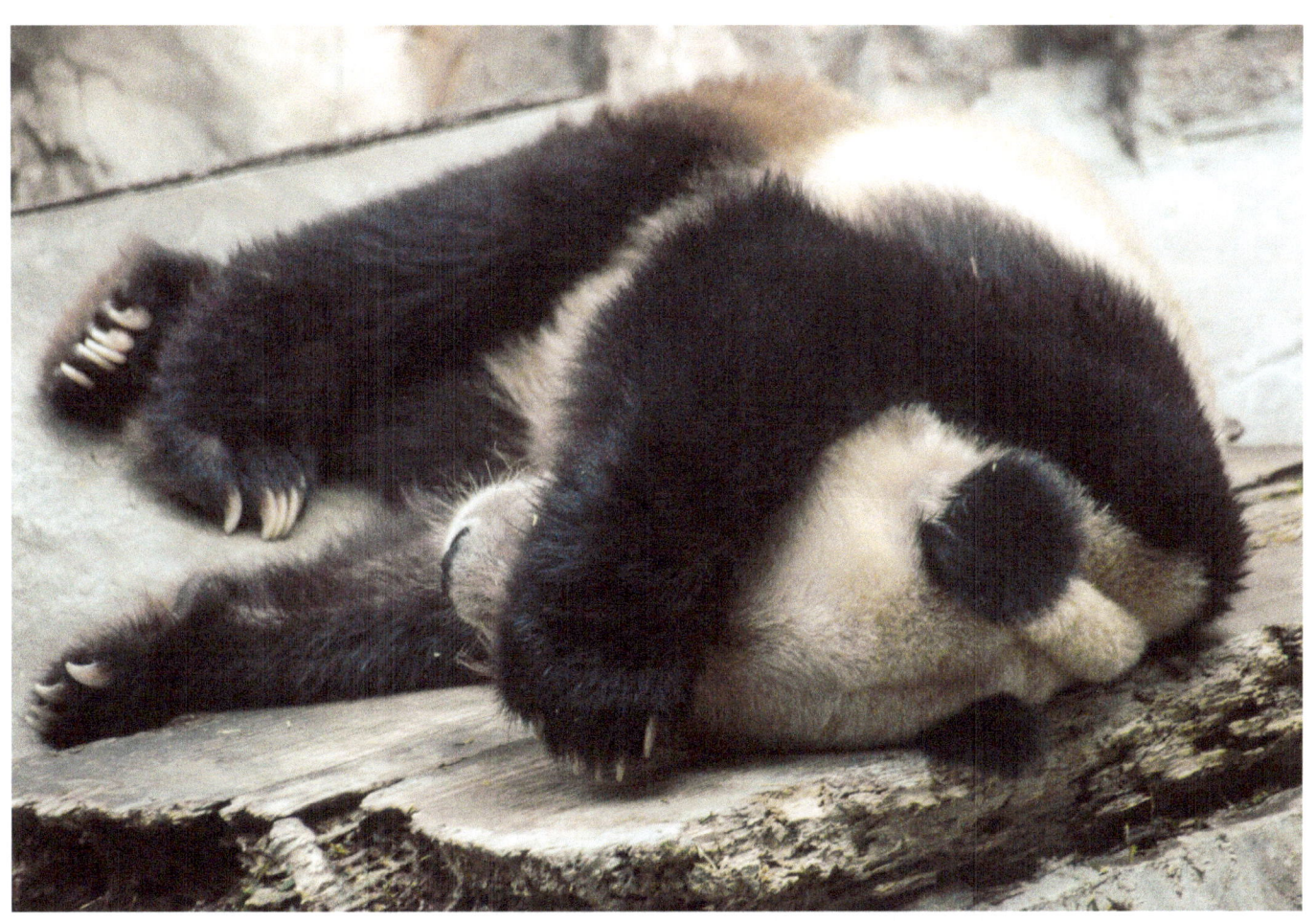

Shortly after arriving at Tsinghua University, I noticed a bicycle repair shop below my fourth-story balcony. I watched the owner in action and decided he would make a good feature story. So when my teaching assistant came to my apartment one day on routine business, I had her go with me to translate.

"Tell him I want to write a story about him and take photographs," I instructed my teaching assistant. "Tell him I am a famous writer from the United States." (I'm not, of course.)

She did and he replied: "Why would anyone want to write about me? I am but a common man." I wanted to say that they make the best stories, but refrained.

I heard the phrase many more times after that, either said in a pathetic, resigned way by a common man or in a condescending tone by someone from the middle class.

Once the constituent of the Communist Party, the common man has been left behind in the market economy. Once a supposedly egalitarian country, China now has a class system and the common man is at the bottom. The poor are common.

When I returned to take photos, the bicycle man said no and it took me a while to develop a relationship in which he would let me take photos. One day he even let me look inside his shop and I would have taken photos there until I realized that the second room in the shop was his living quarters. I felt I was violating his privacy and did not take photos or go any farther into his space.

I took photos from time to time, sometimes of him at work and other times watching the daily mahjong game that was played outside his shop, and waved when I walked by, but I never pursued the story. I think I already know it. And it is sad.

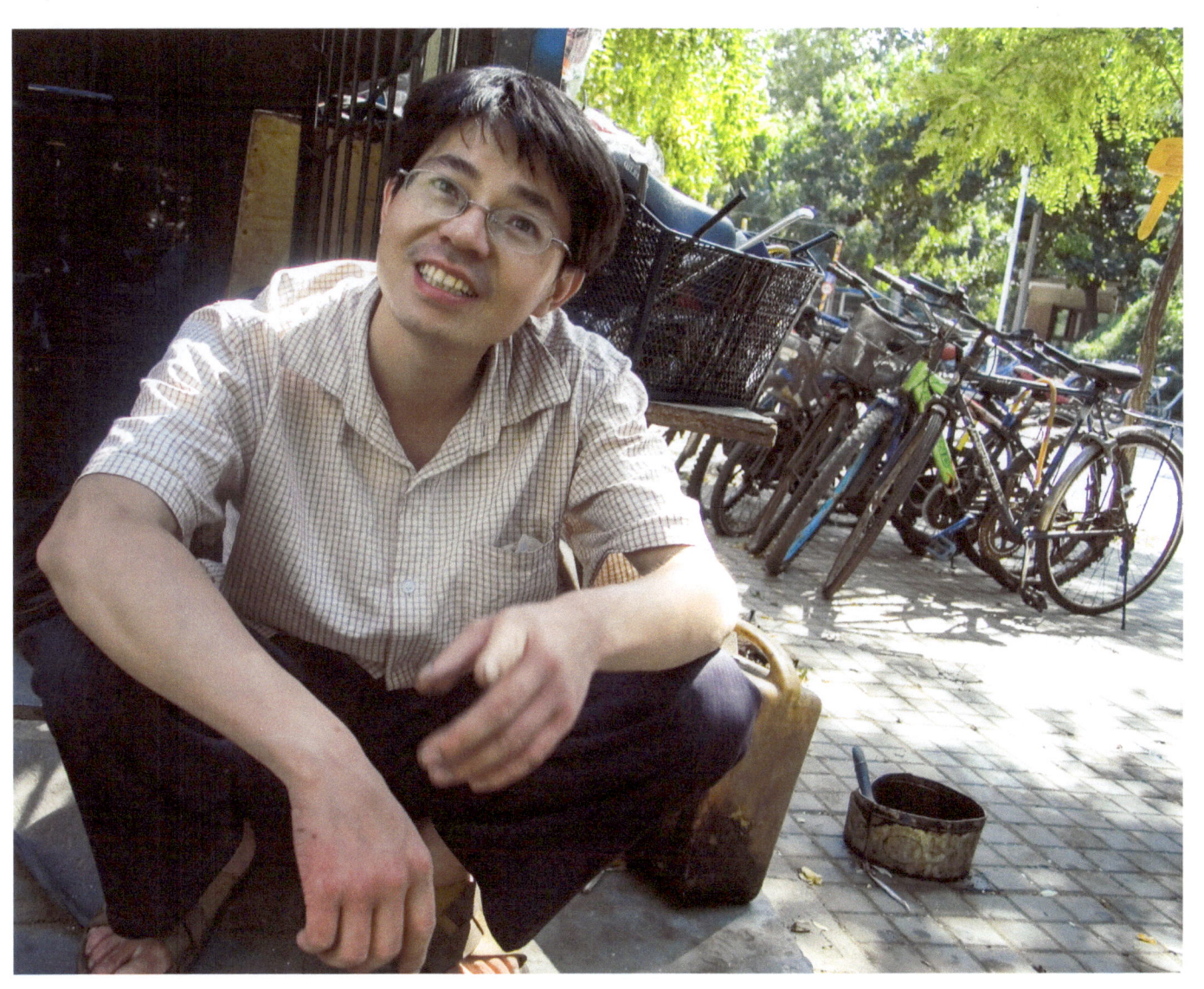

Beijing 2005

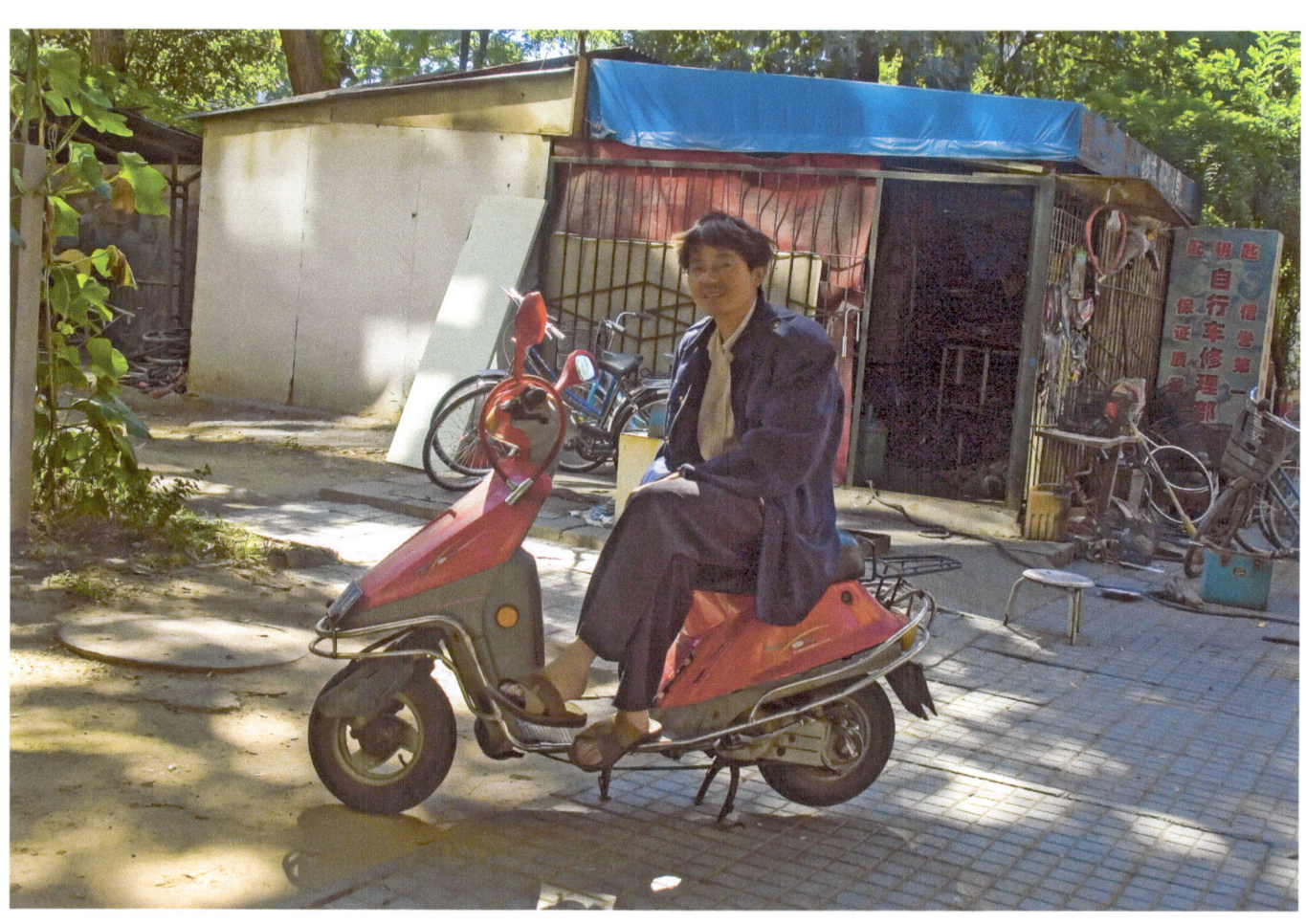

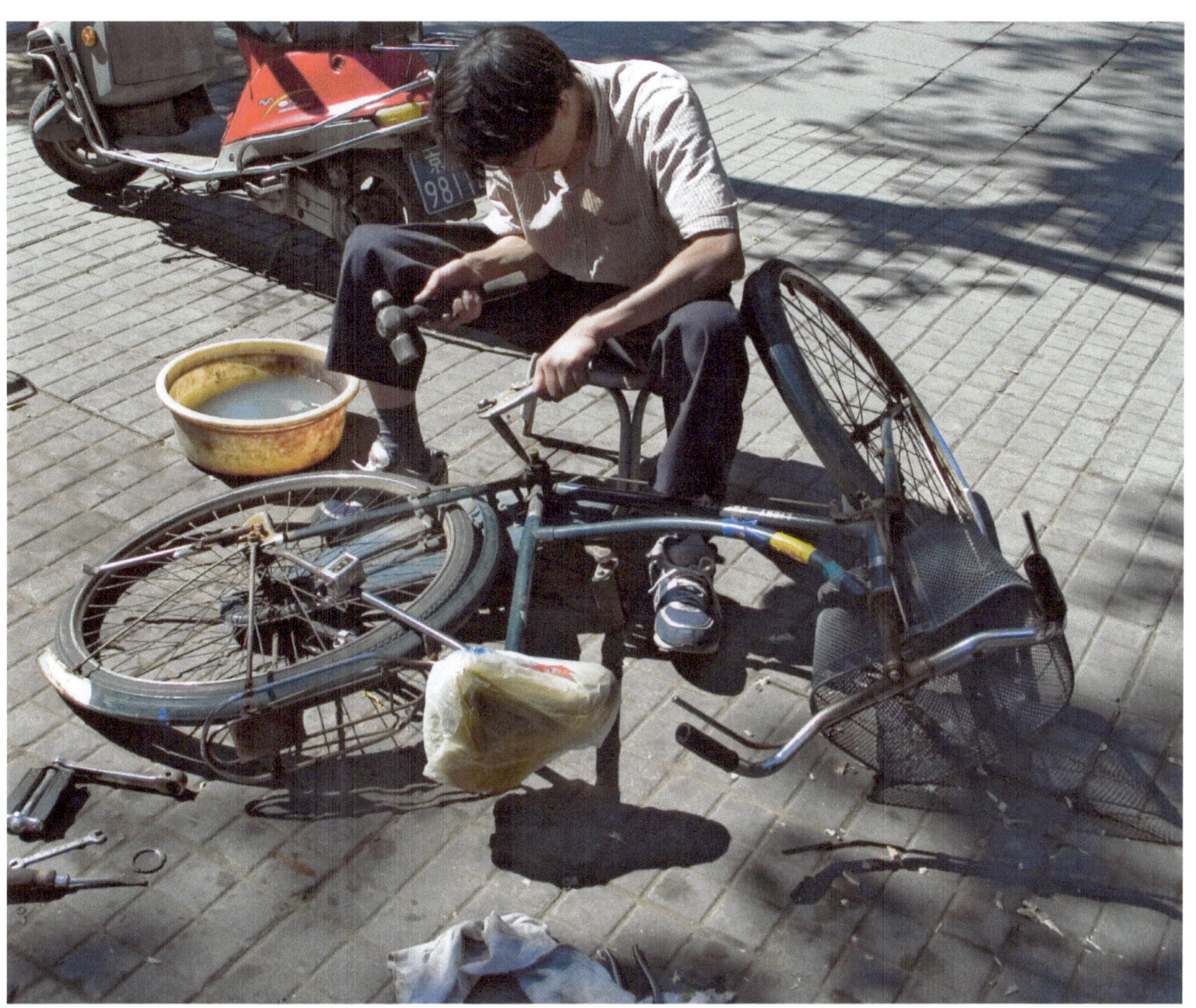

As my host in Chongqing and I approached the restaurant we were going to have lunch at, I noticed the wait staff at the contiguous restaurant skipping rope and otherwise having a little bit of fun before the lunch crowd arrived. I walked toward them with my camera and started shooting. Most quit their games and went inside—but only momentarily. The only male in the group remained and skipped rope as I shot. Suddenly, two of the females took over and performed for me, one skipping rope and the other playing hackey sack. I nicknamed them "The Showoffs."

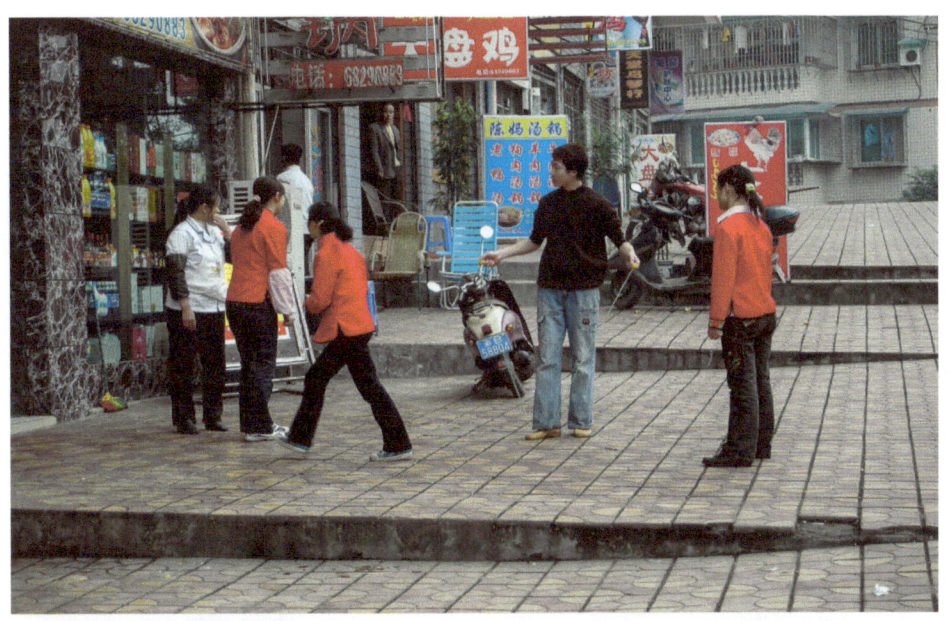

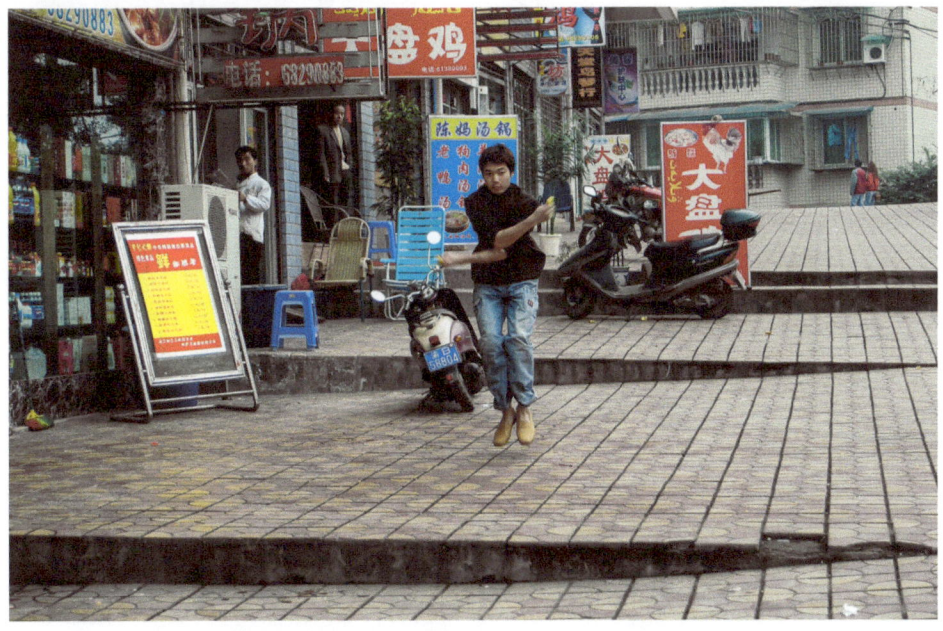

Chongqing 2005

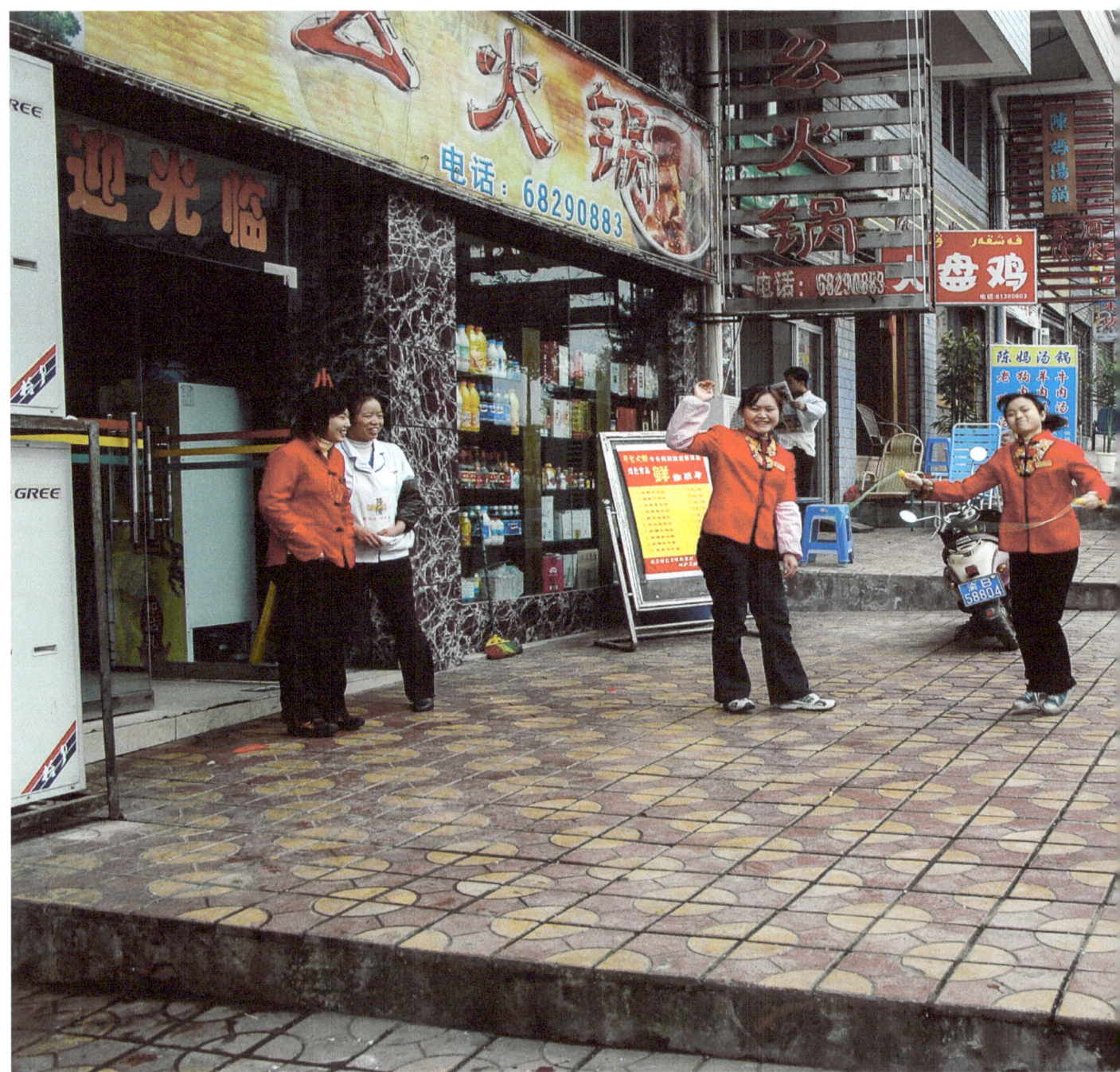

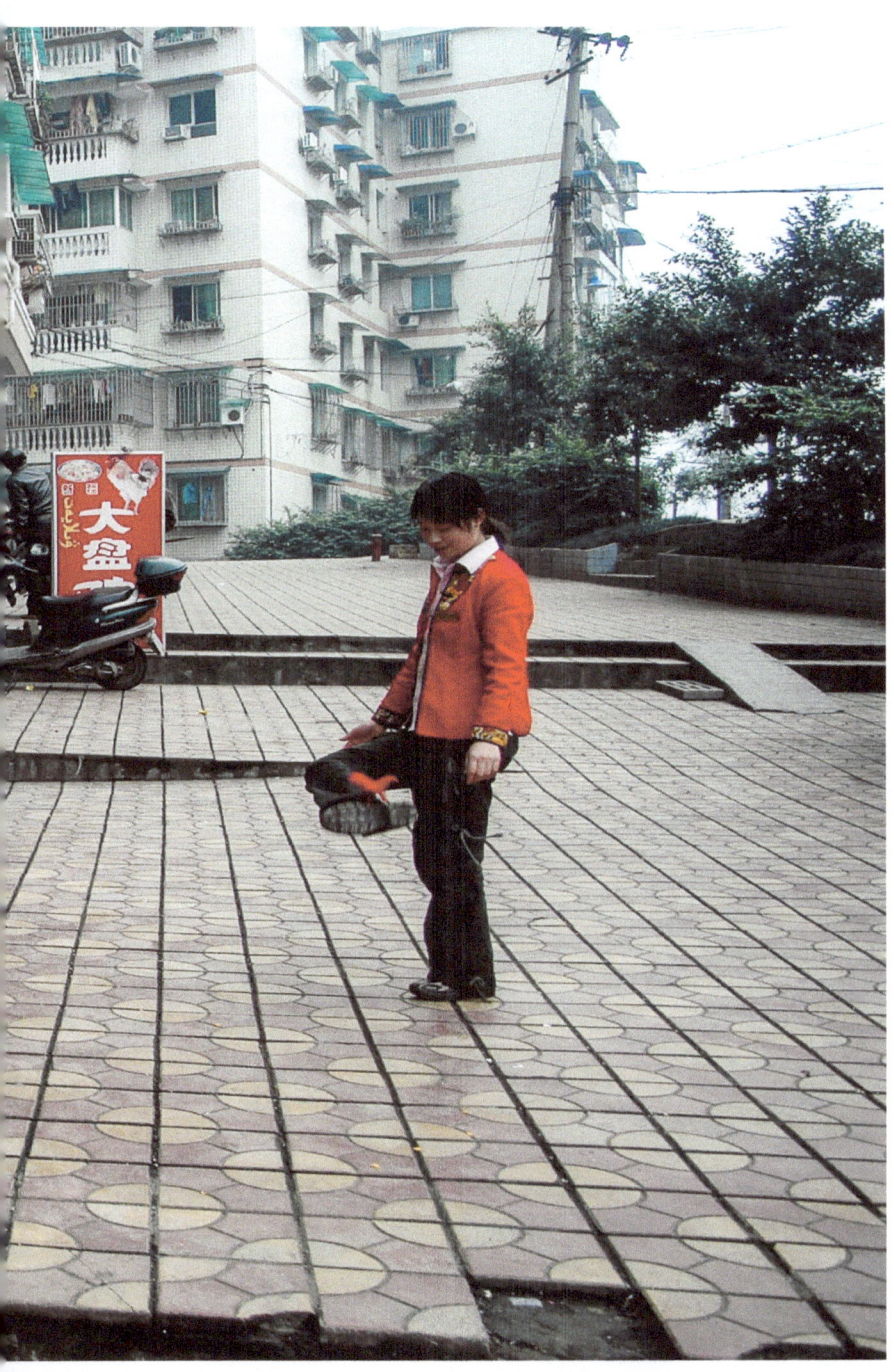

As I said in the opening essay, more than anything, the people of china draw me back. They are non-judgmental and accept you as you are.. The Chinese have also become more accommodating to western tourists with cameras. I think that reflects the explosion of camera use in China and the fact that Chinese have much greater freedom of movement than they did even in 1995 and therefore visit more places in their own country. It seems, especially around culture sites, everyone has a camera. I prefer the candid photograph to the posed, but when shooting portraits, I had to ask and the consenting people posed. So the photos that follow are a mix.

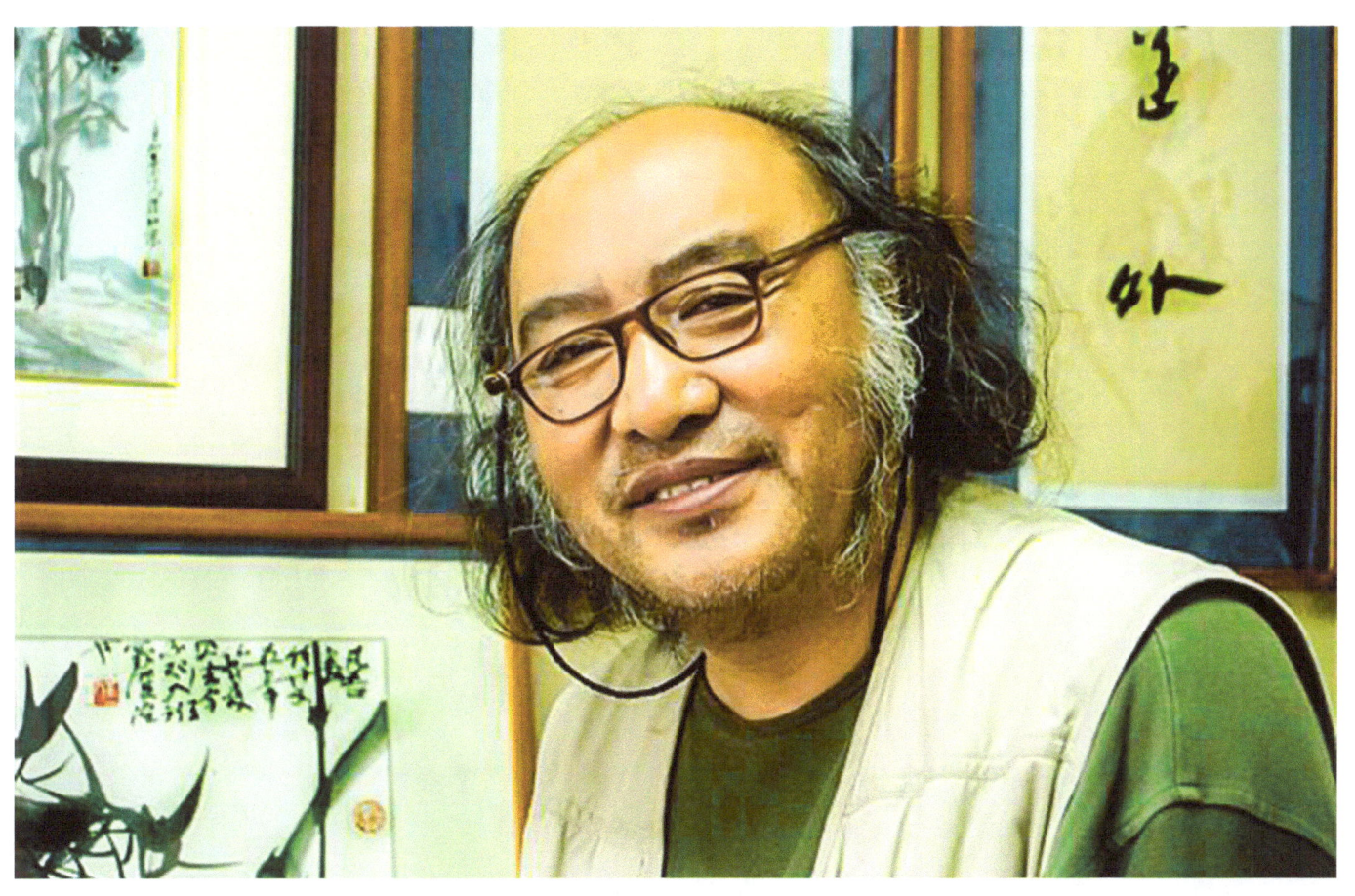

Beijing 2005

Xian 2005

Hong Kong 2002

Wushan 1999

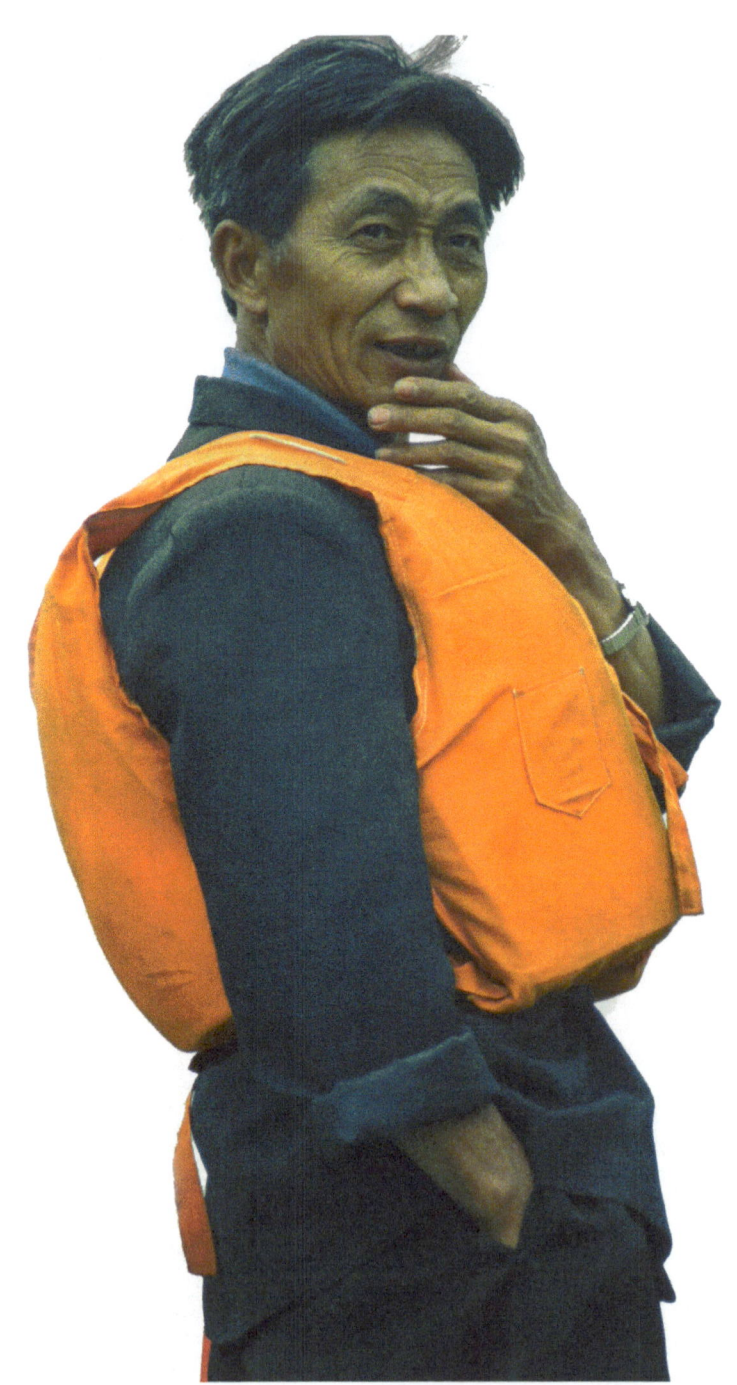

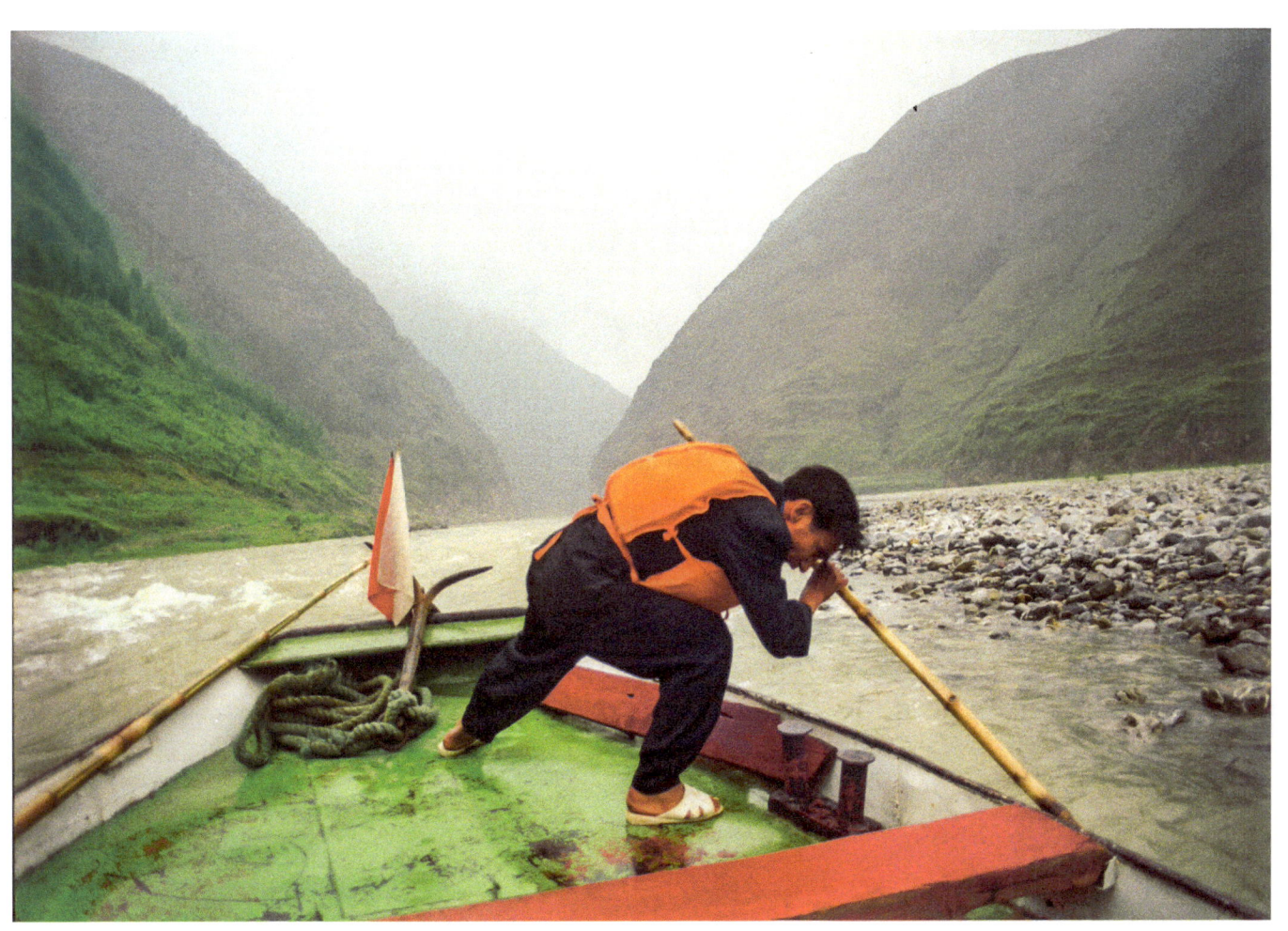

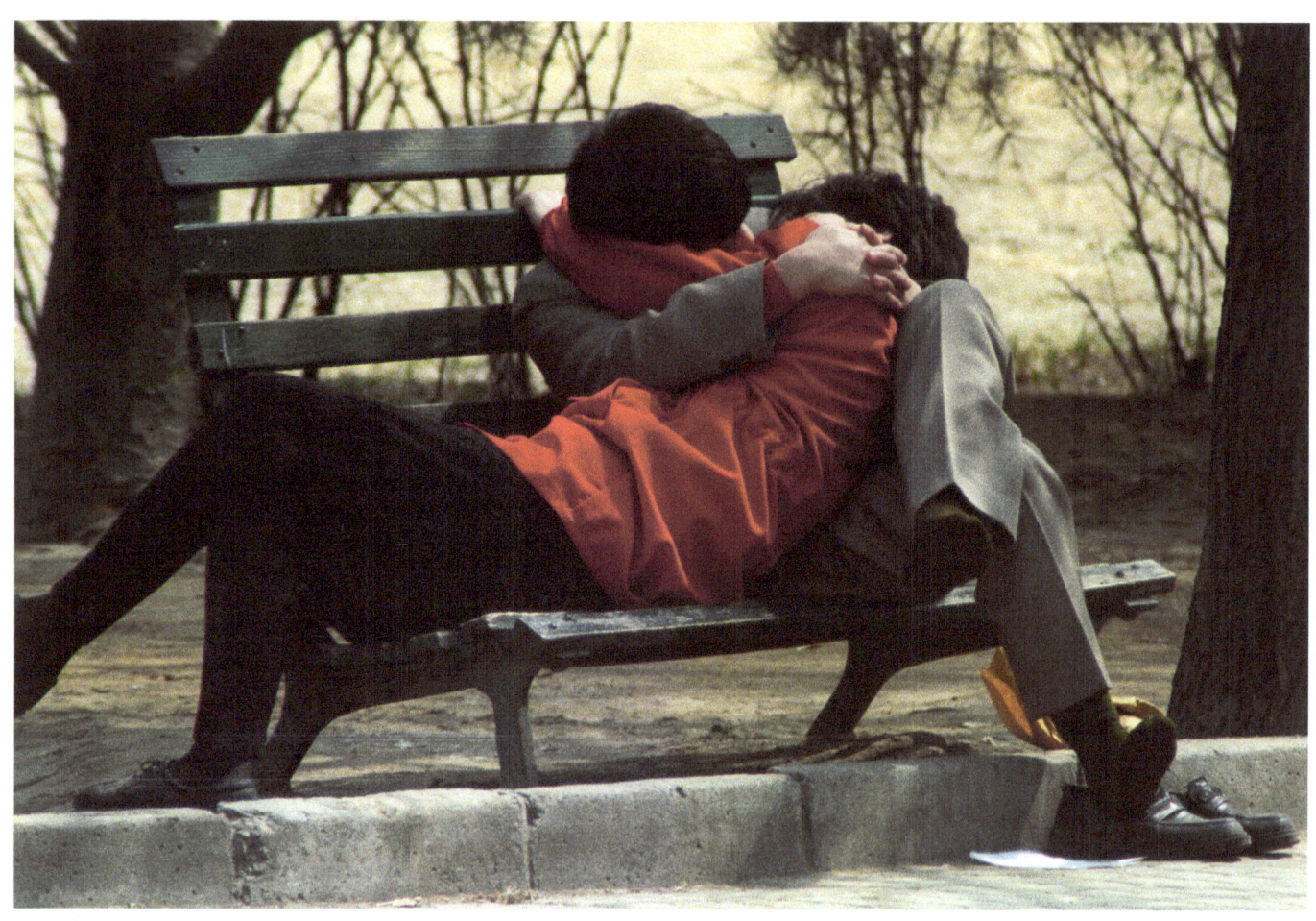

Beijing 1994

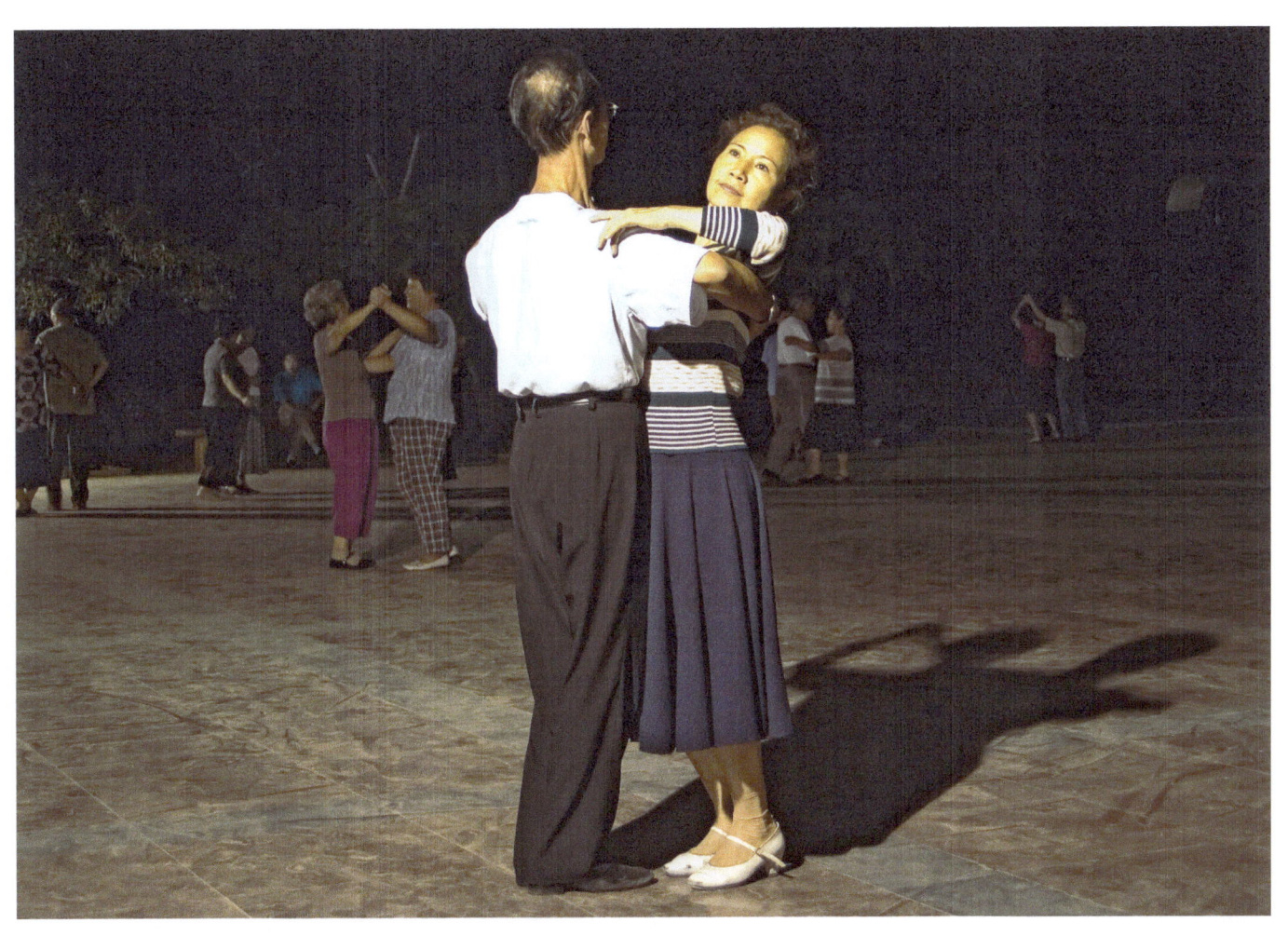

Beijing 2005

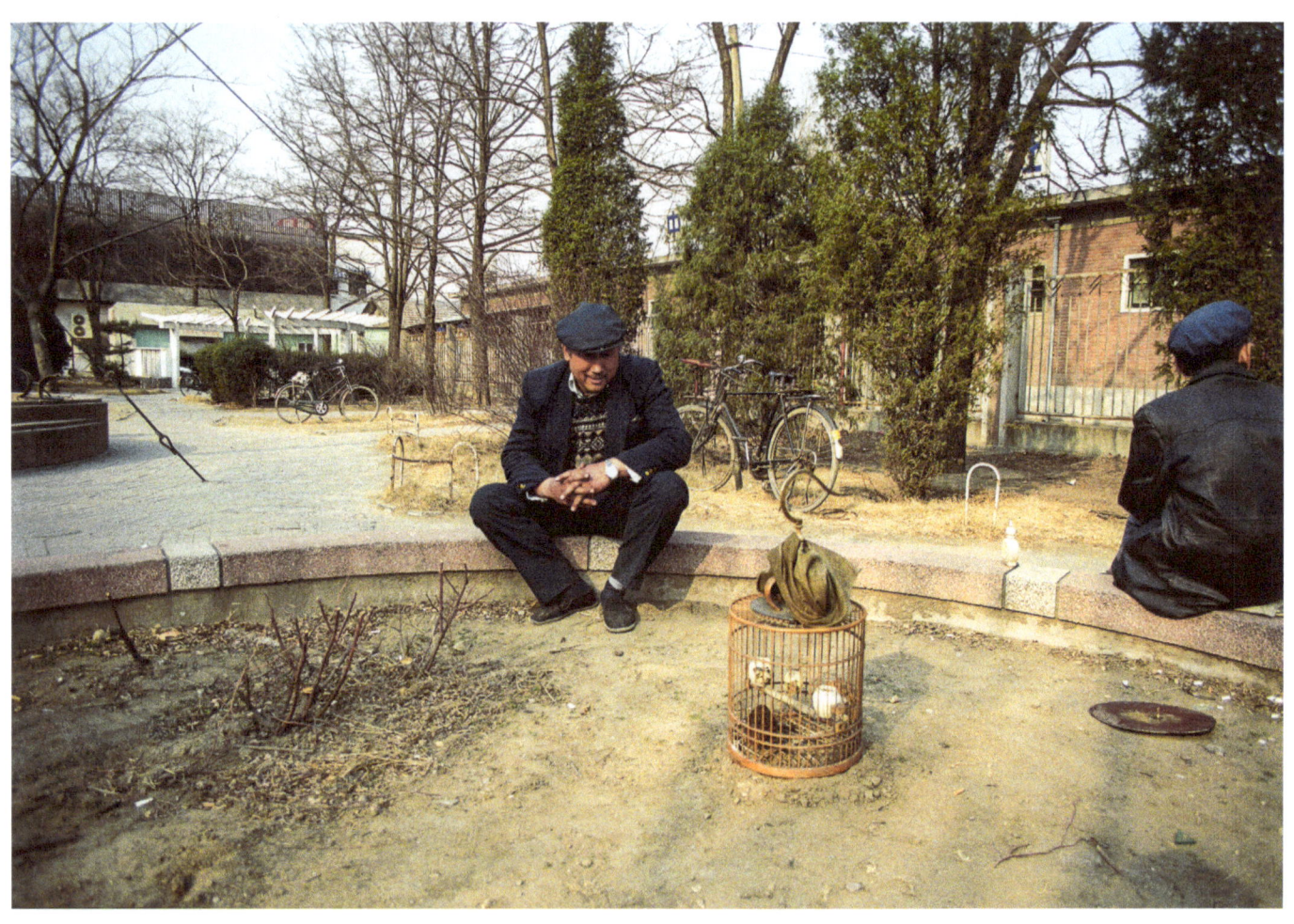

Beijing 1994

Xian 2001

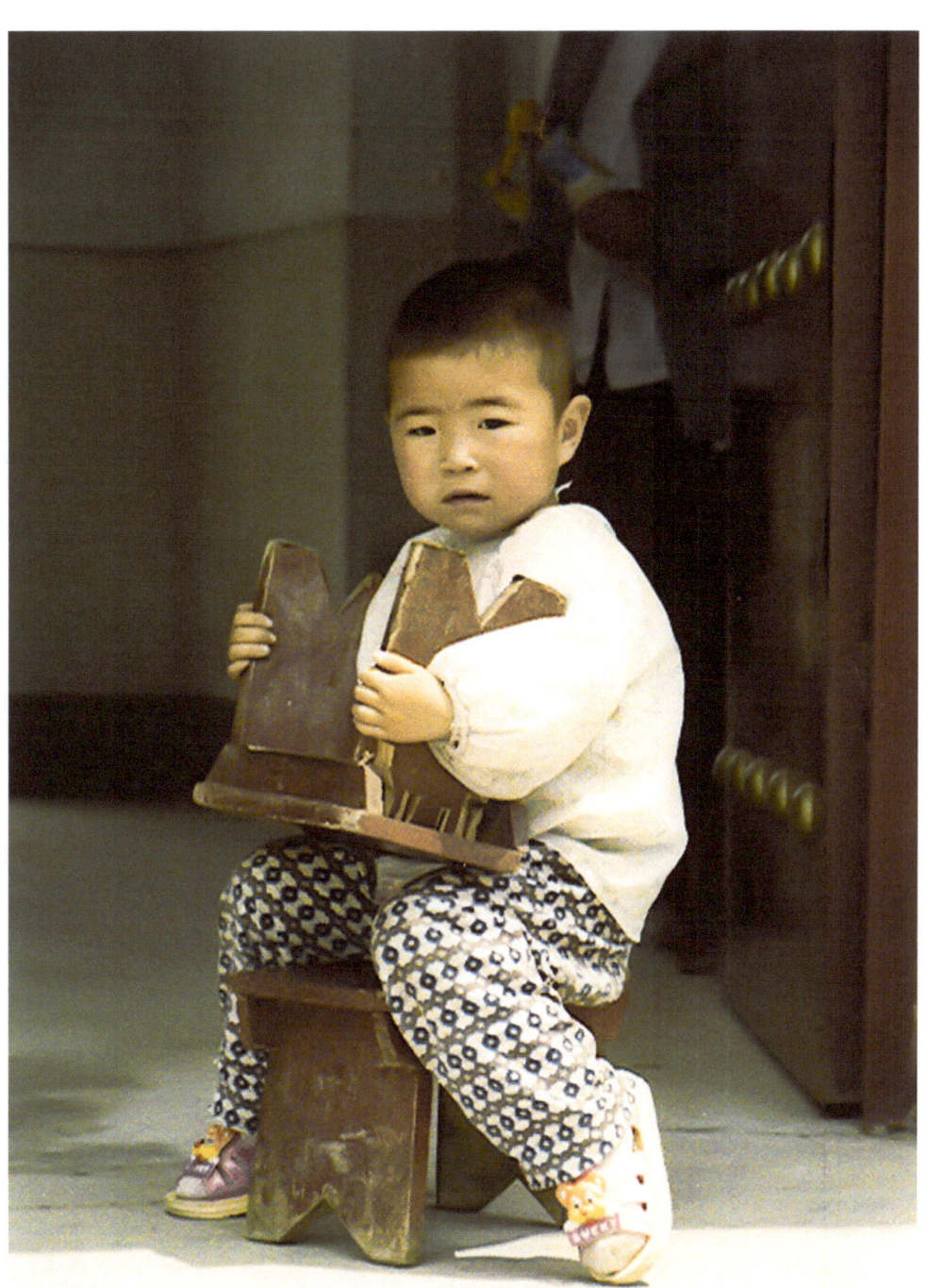

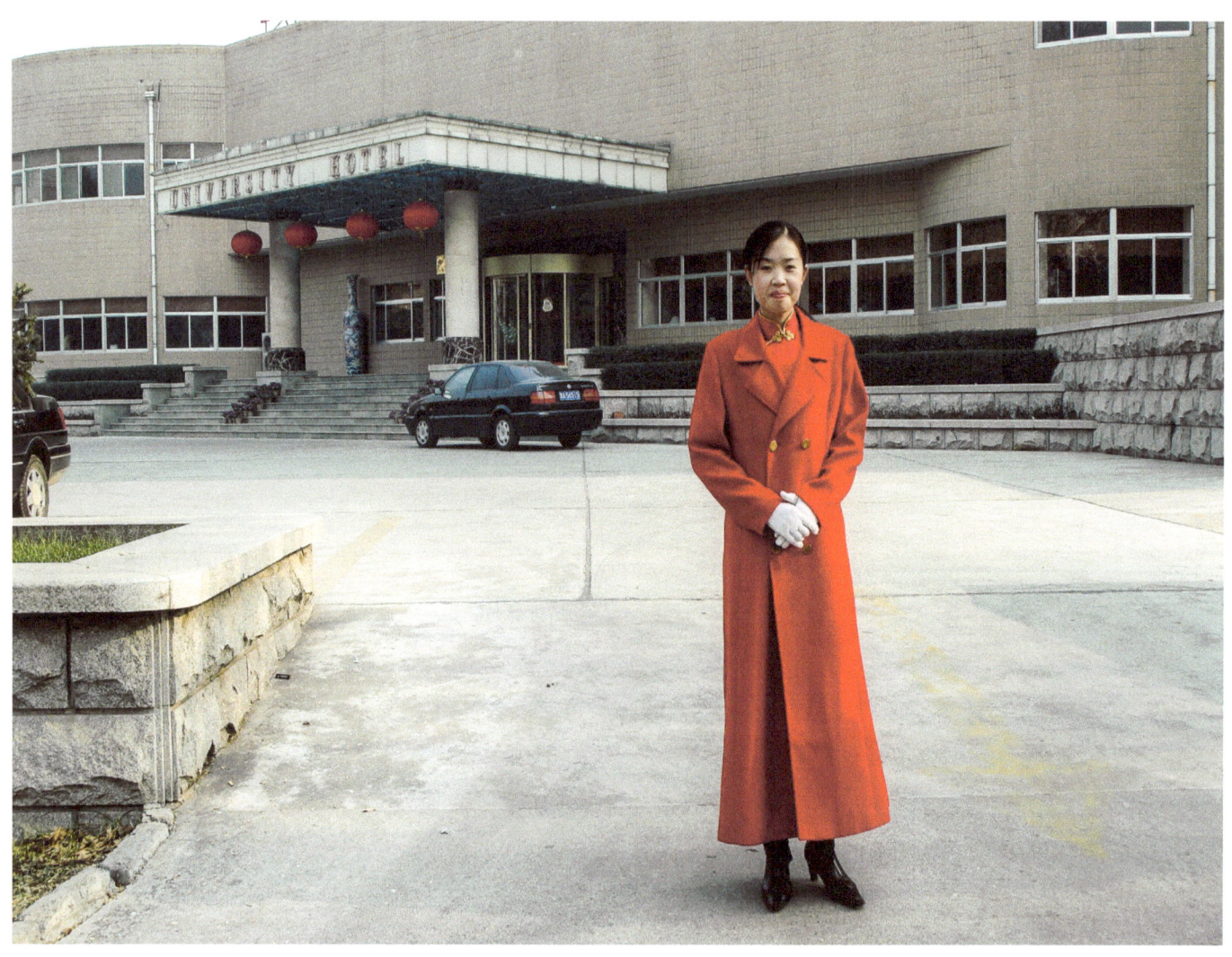

Jinan 2005

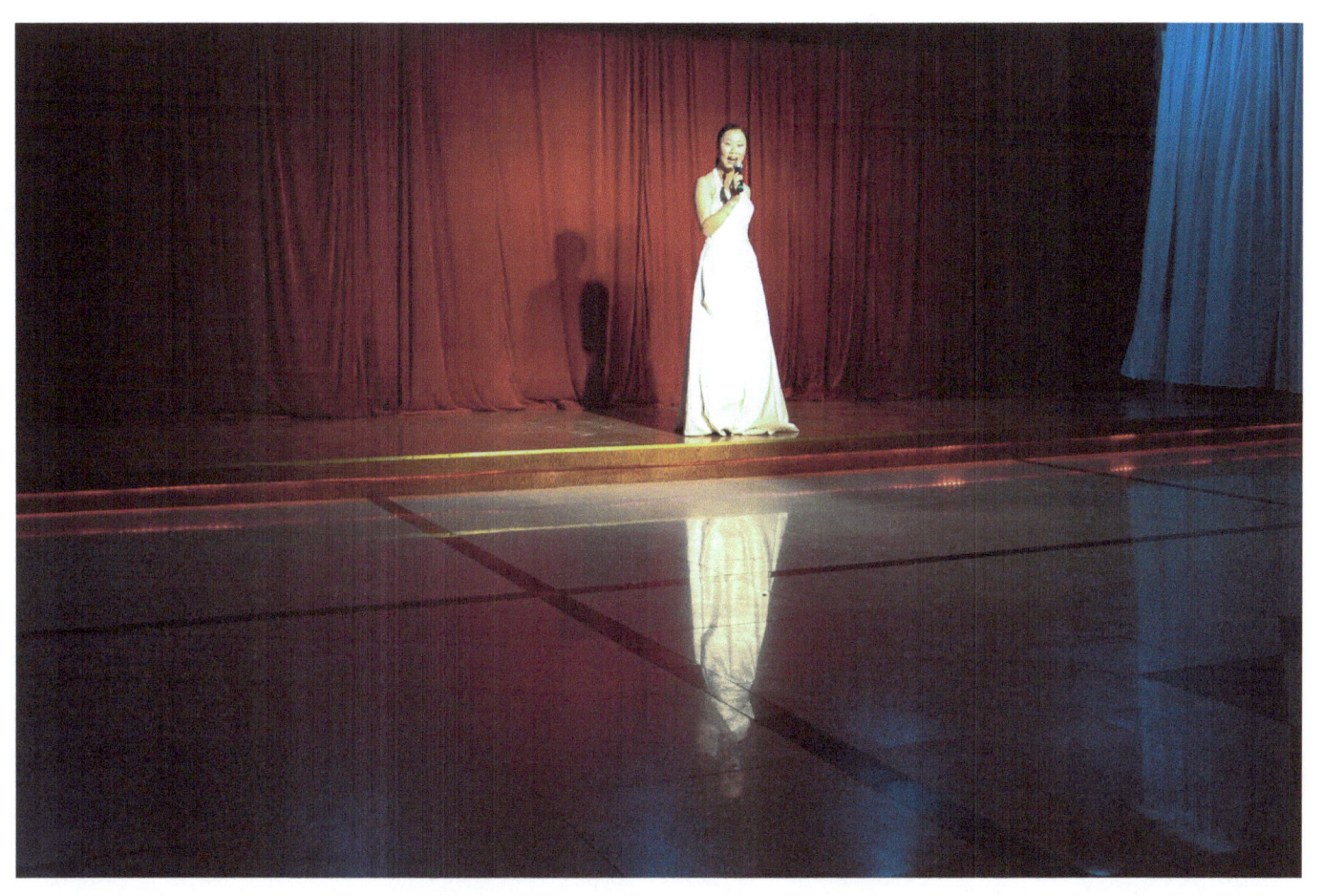

Hutou 2005

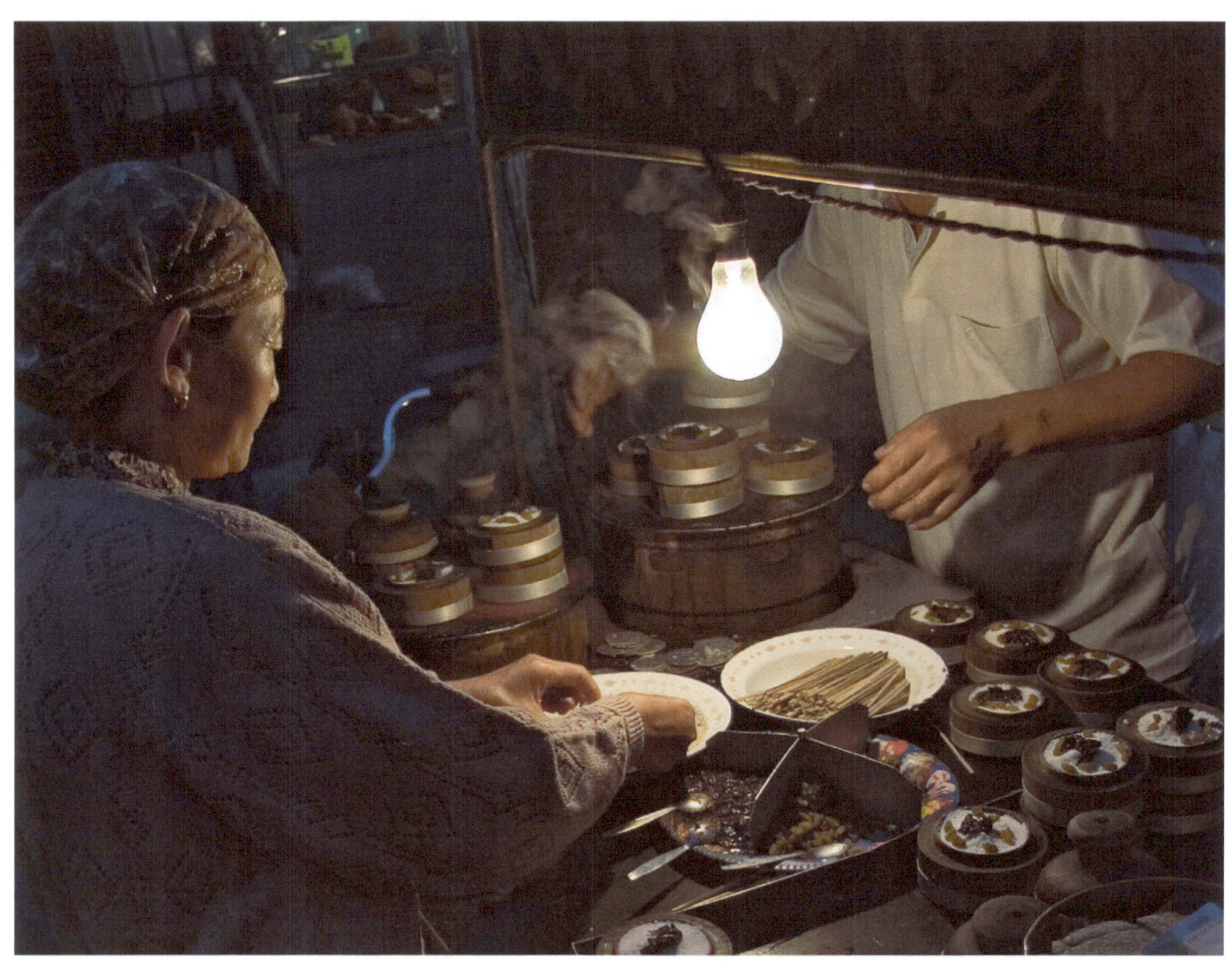

Xian 2005

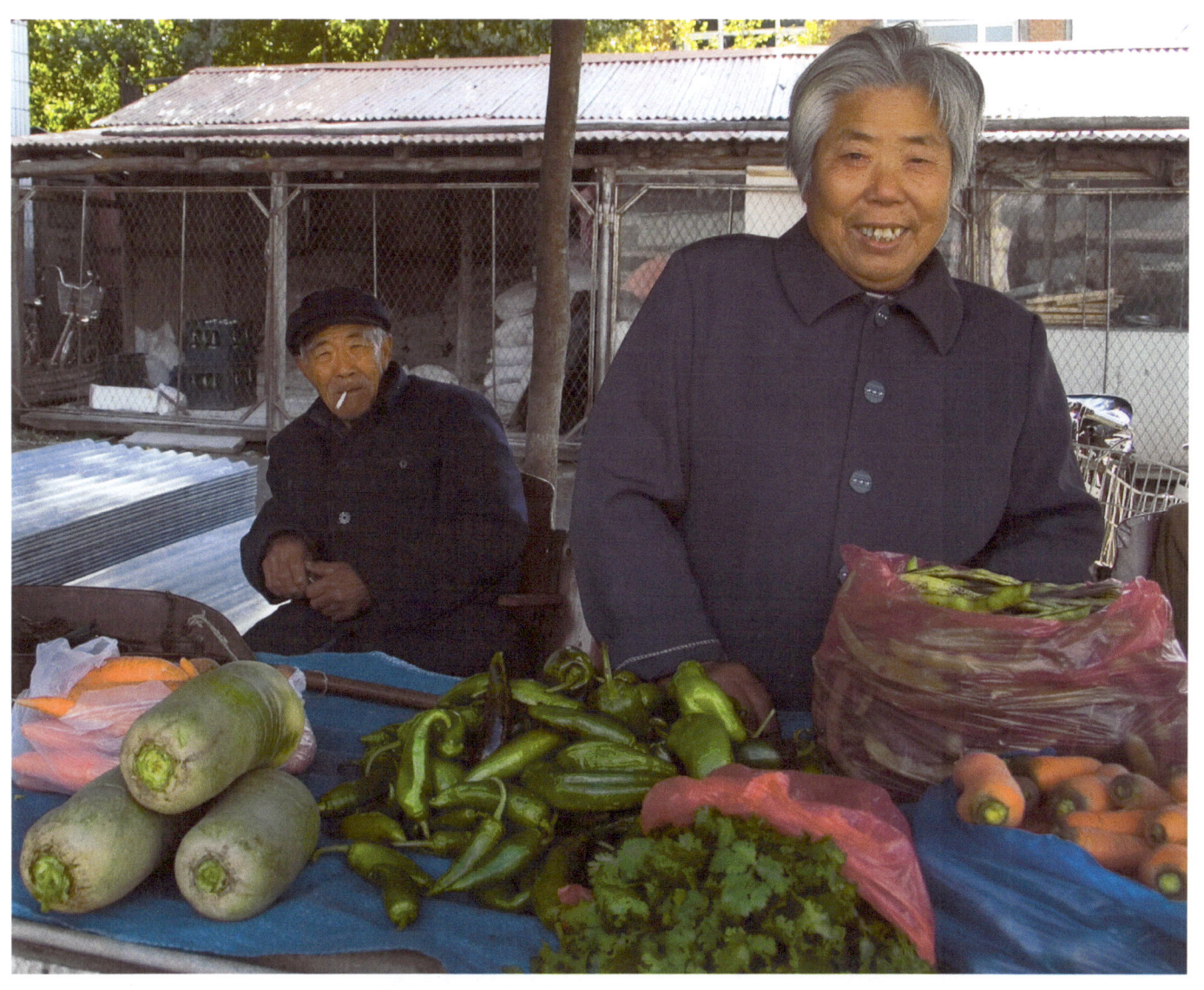

Hutou 2005

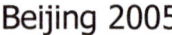
Beijing 2005

Jixi 2005

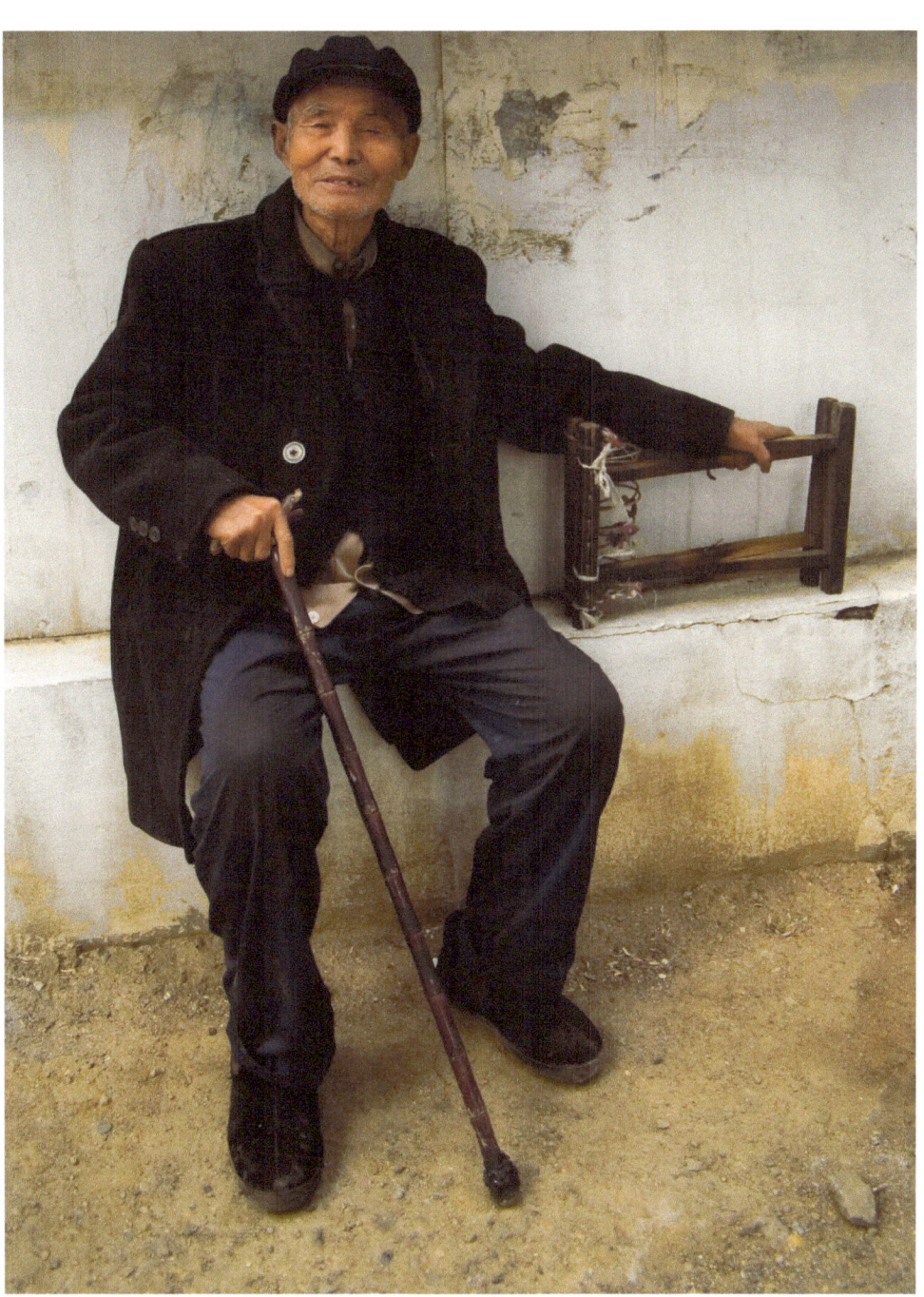

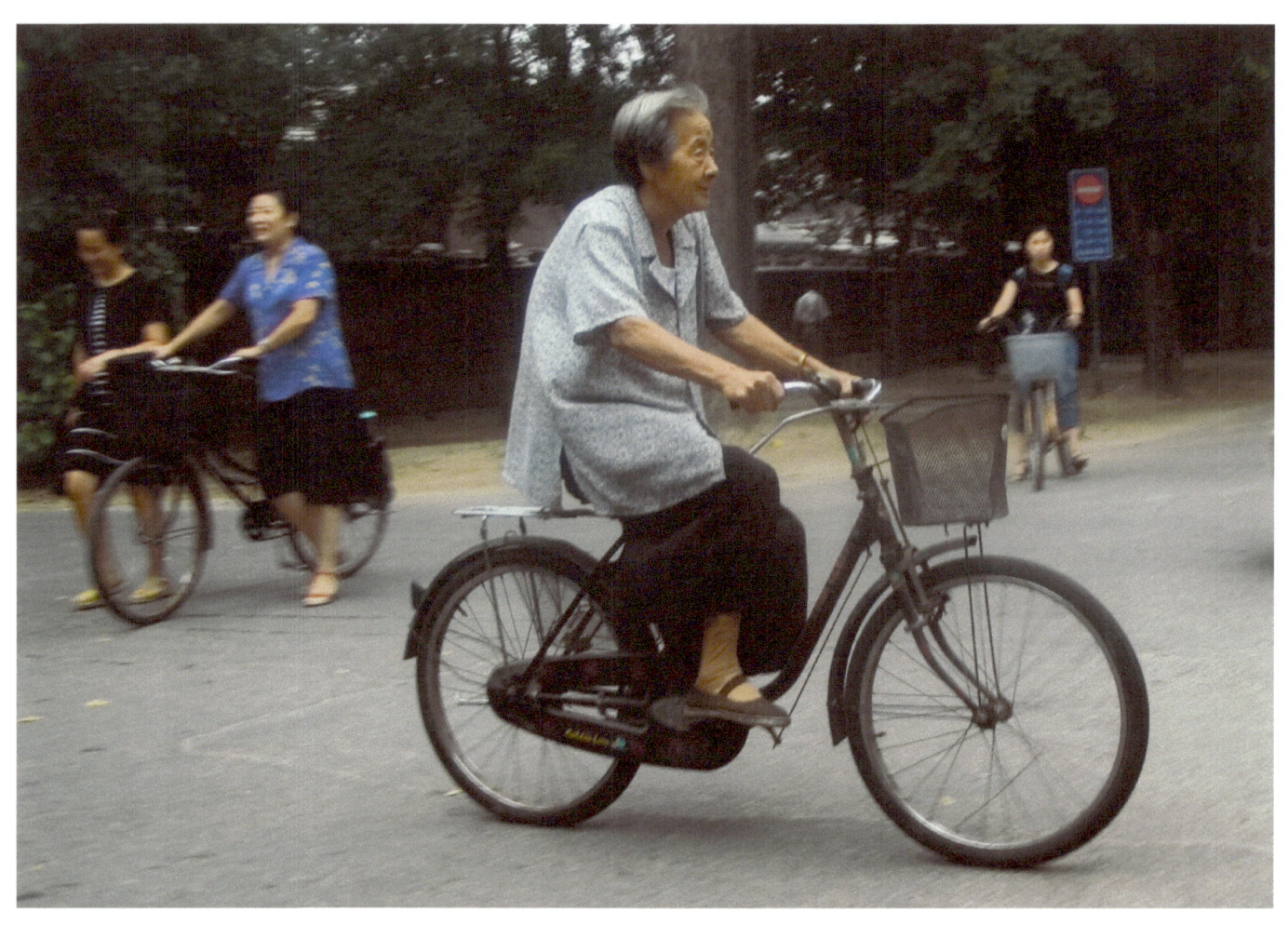

Beijing 2005

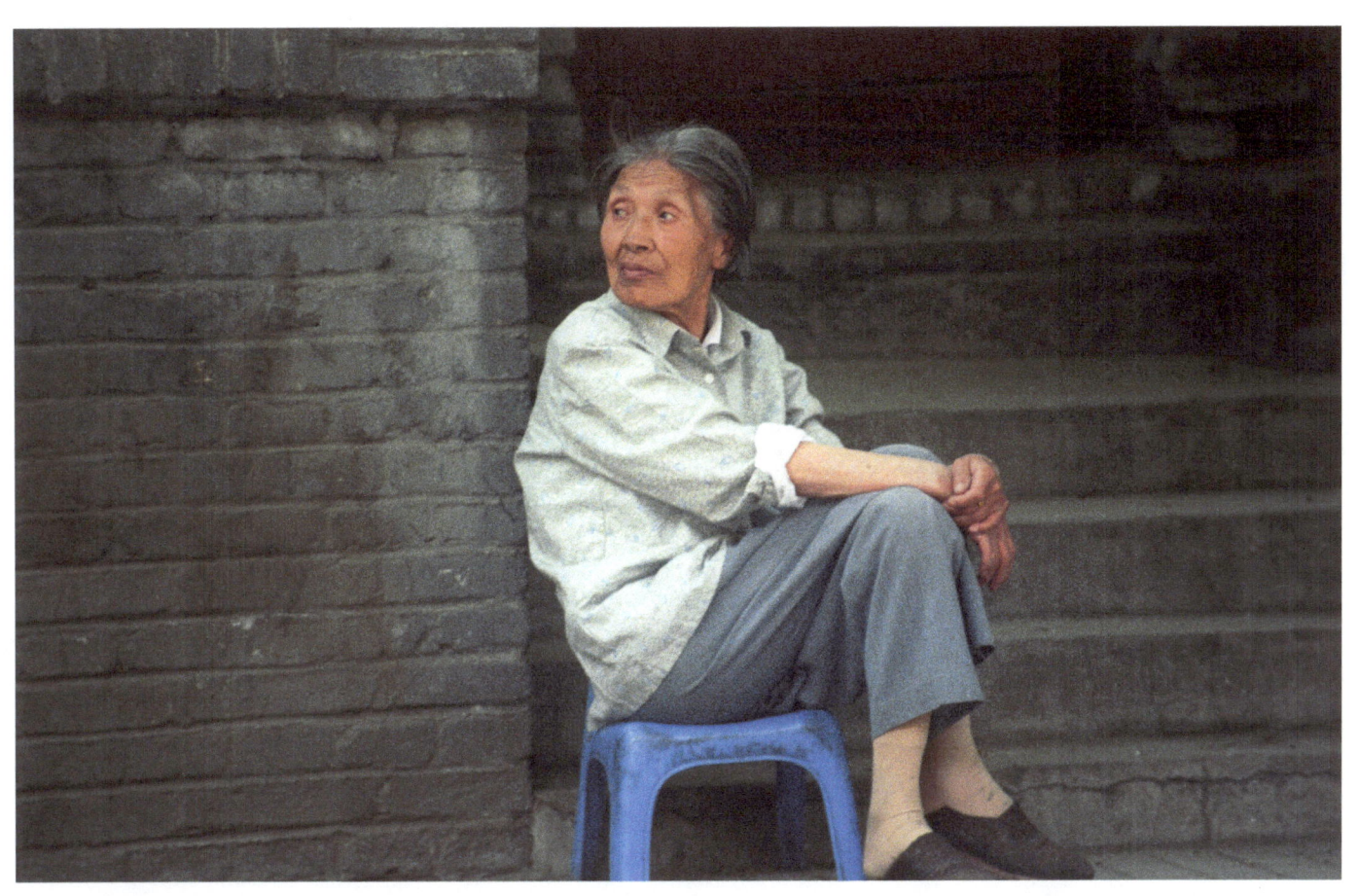

Beijing 1994

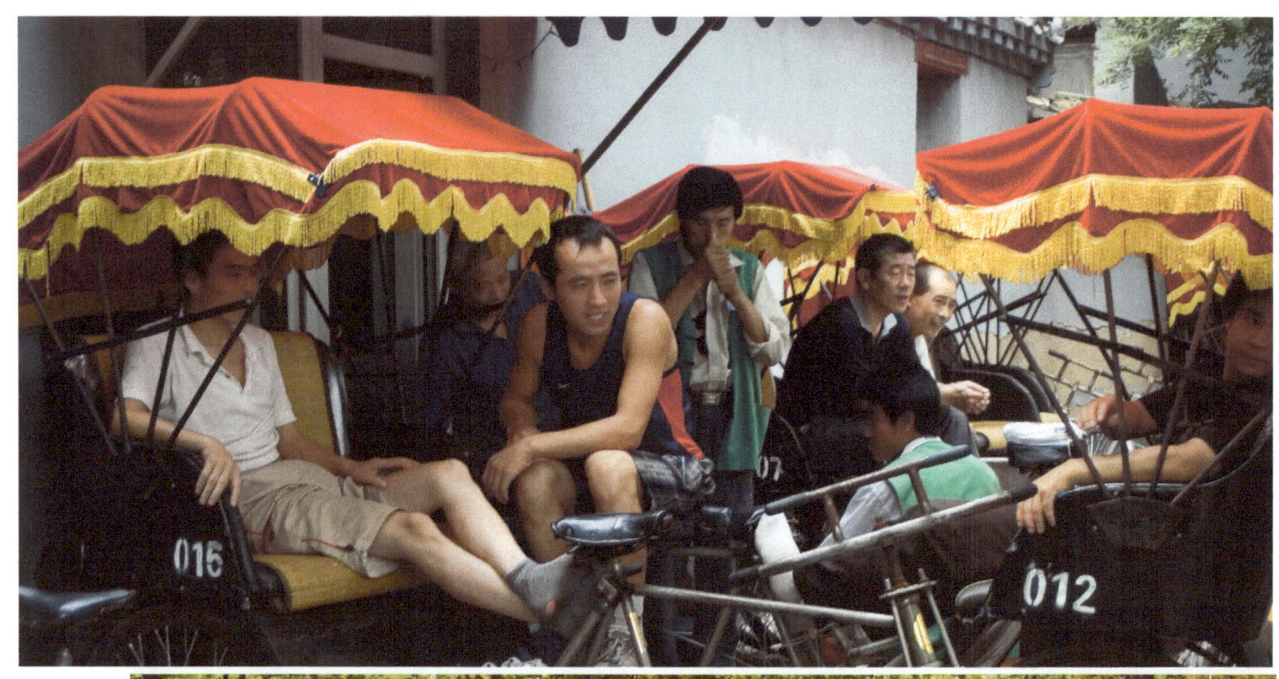
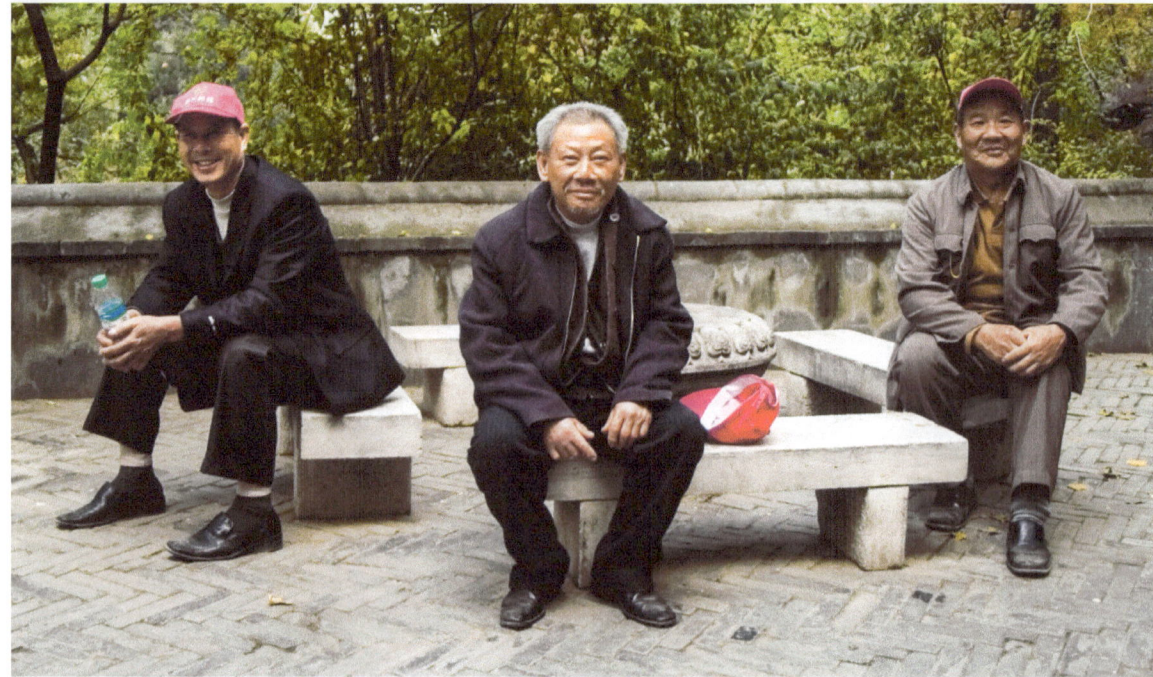

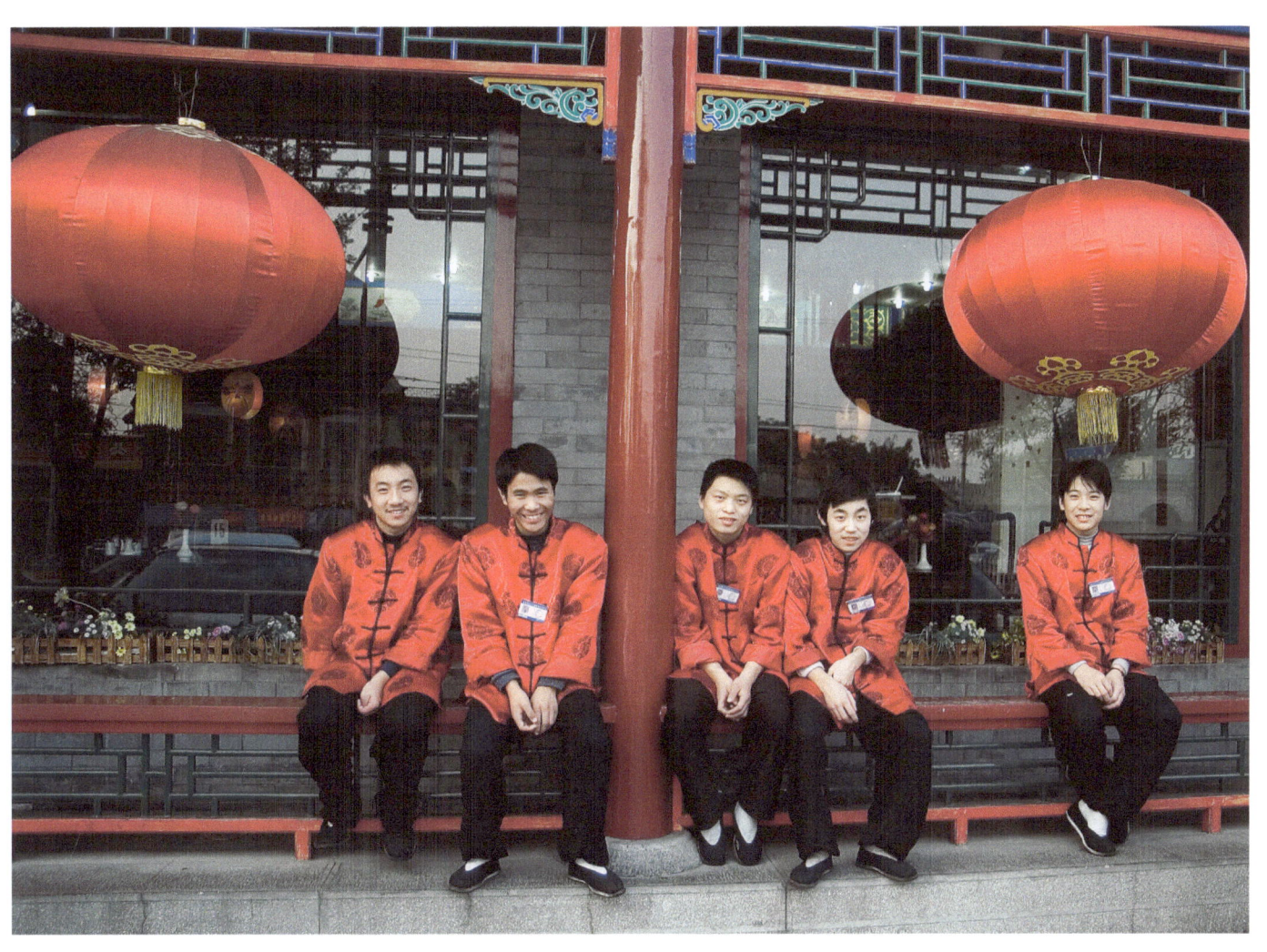

Beijing 2005

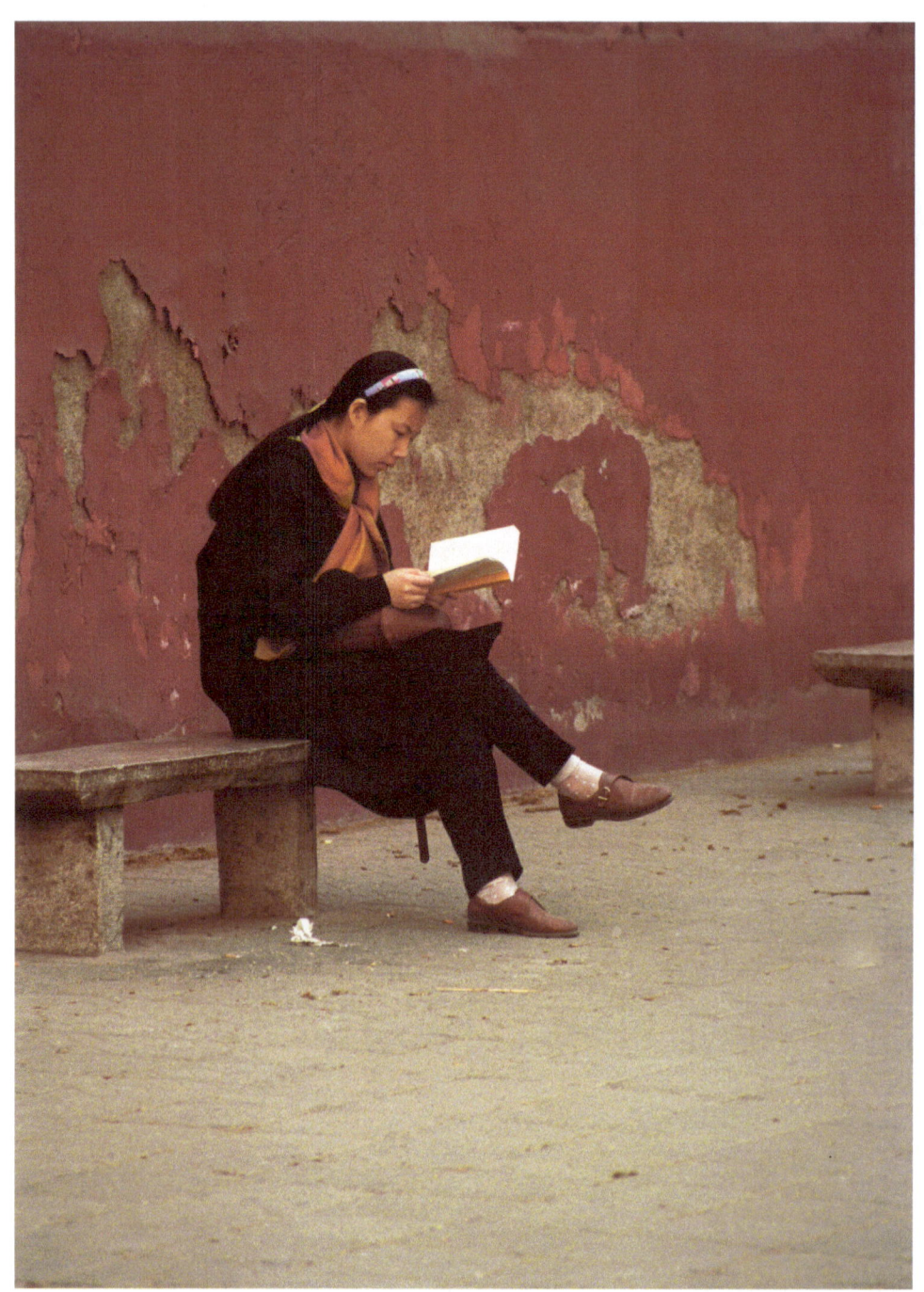

Beijing 1994

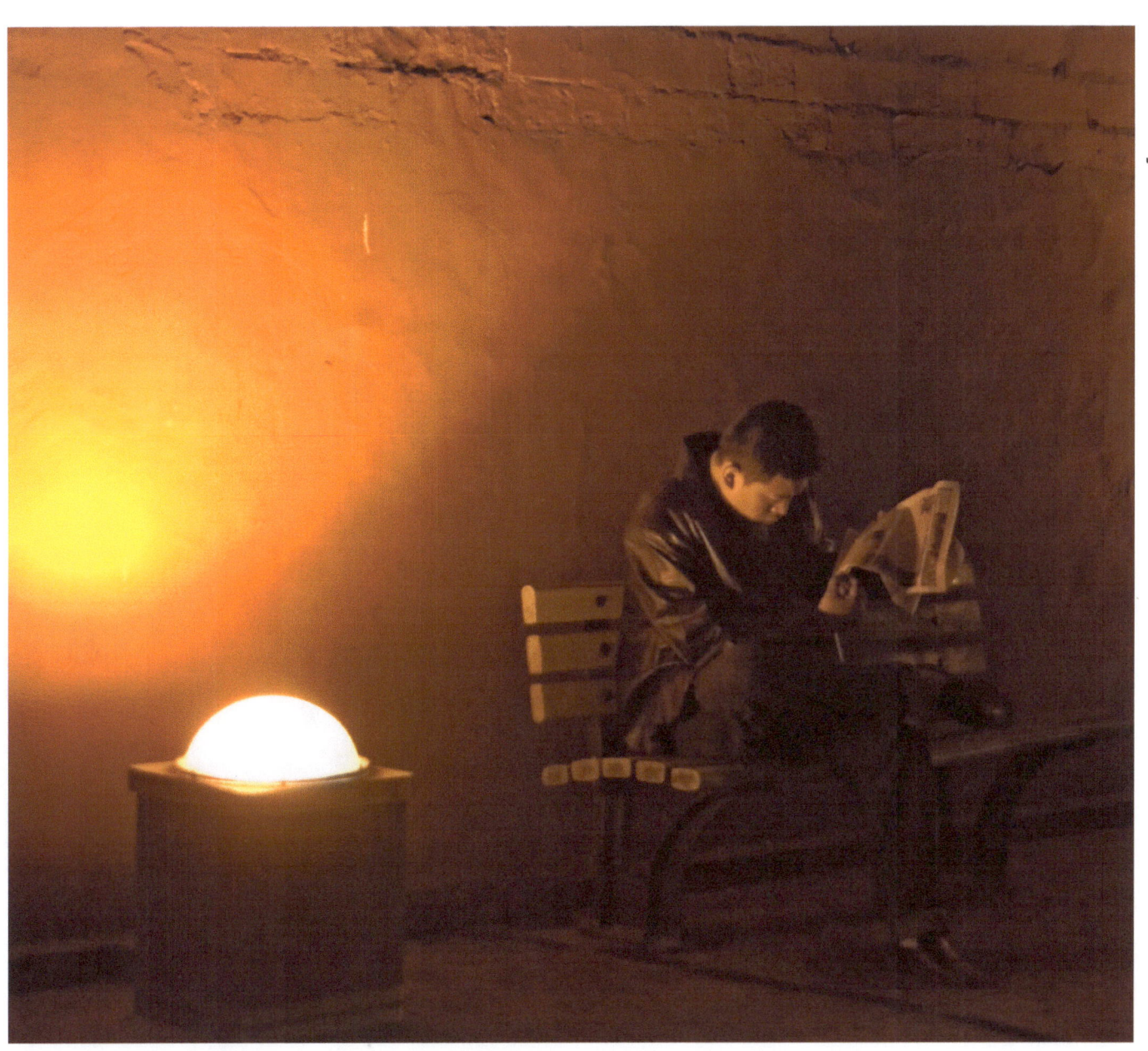

Beijing 2005

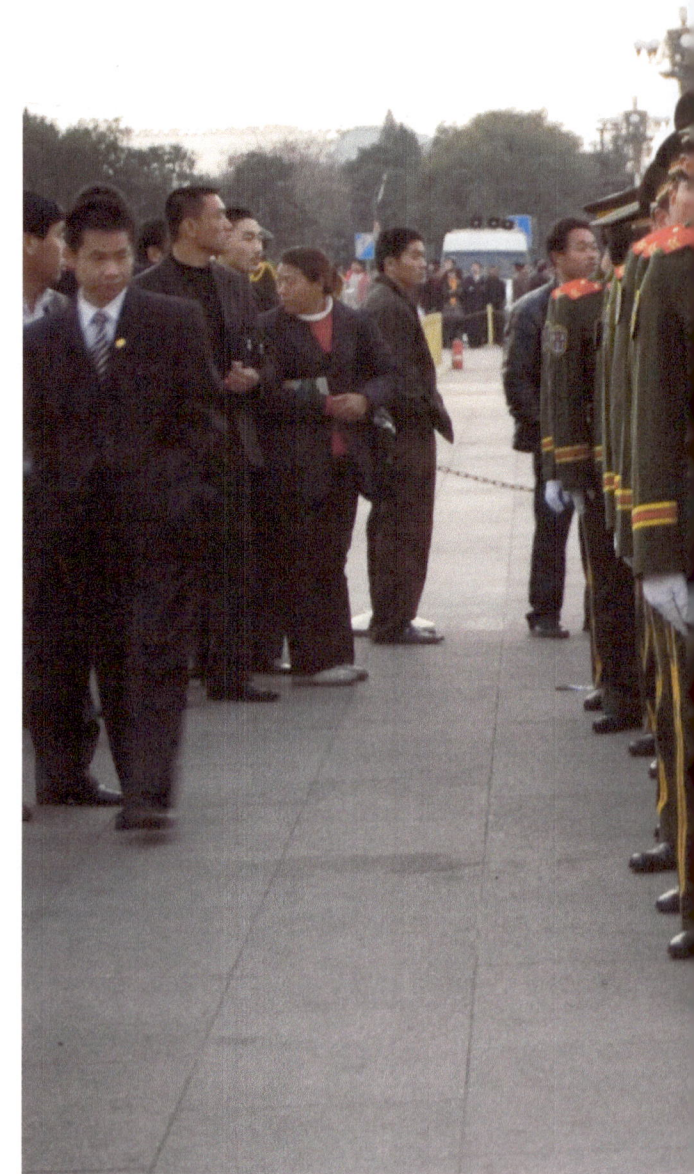

Beijing 2005

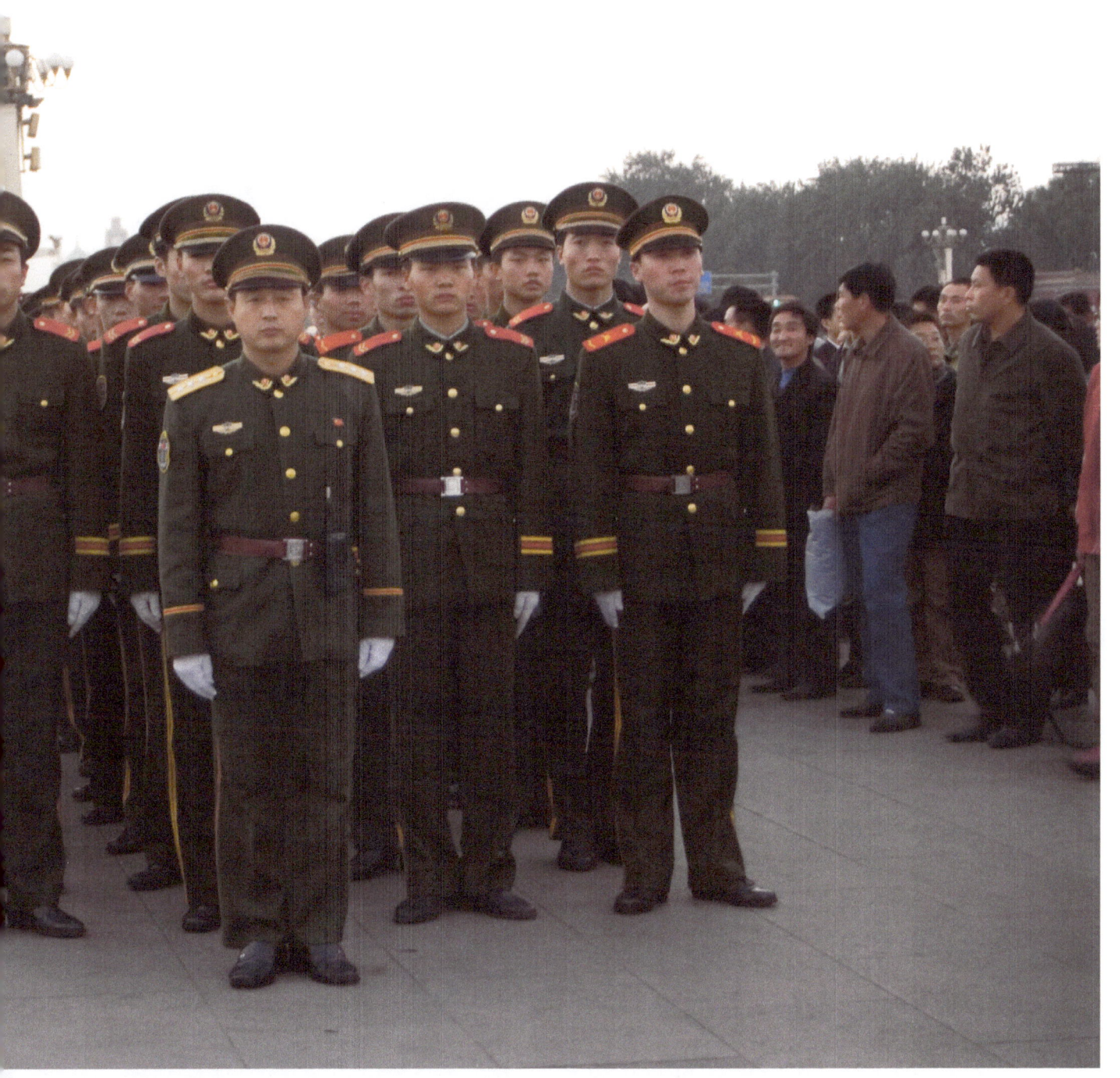

Suzhou 1994

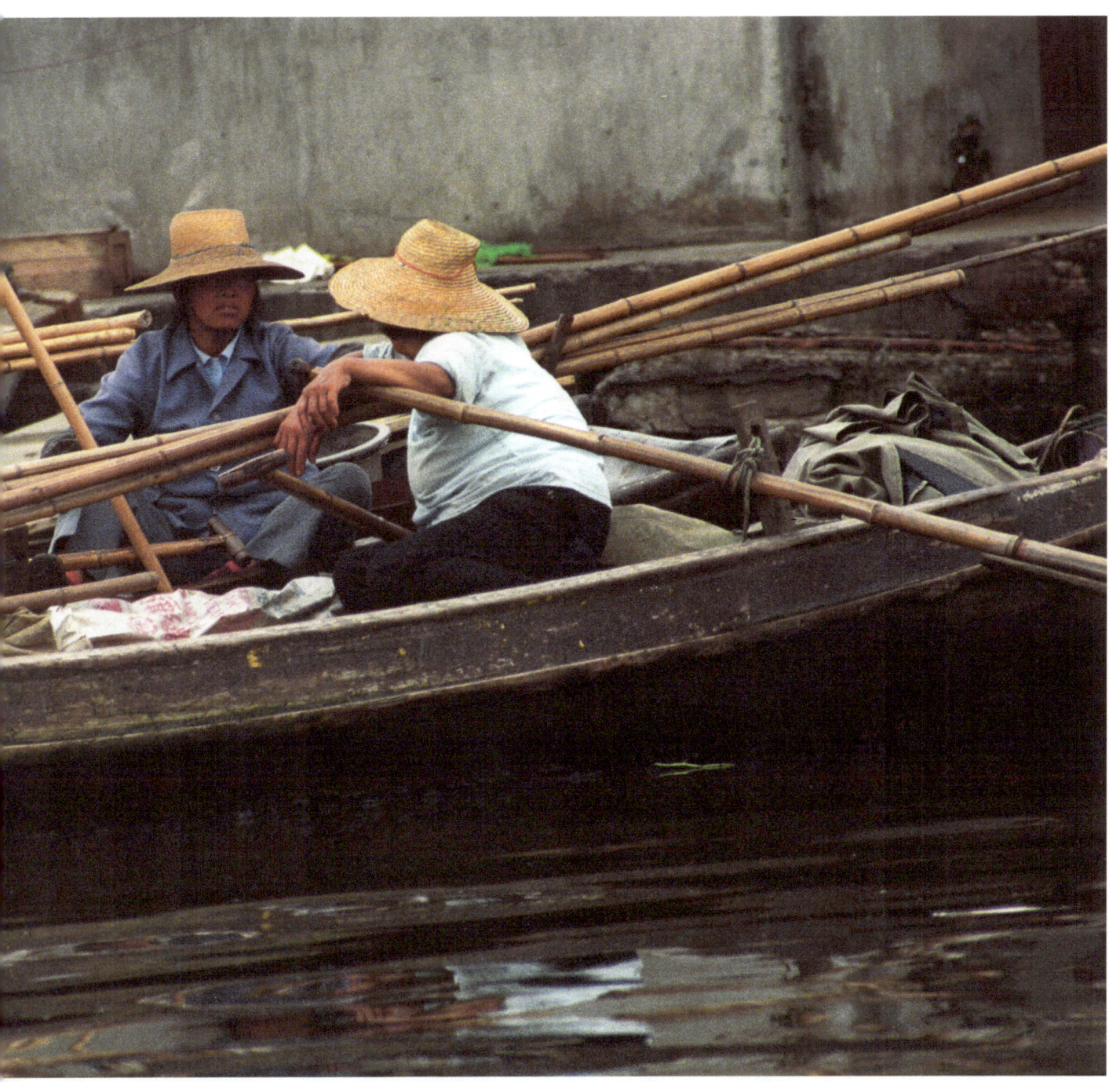

Beijing 2005

Beijing 2005

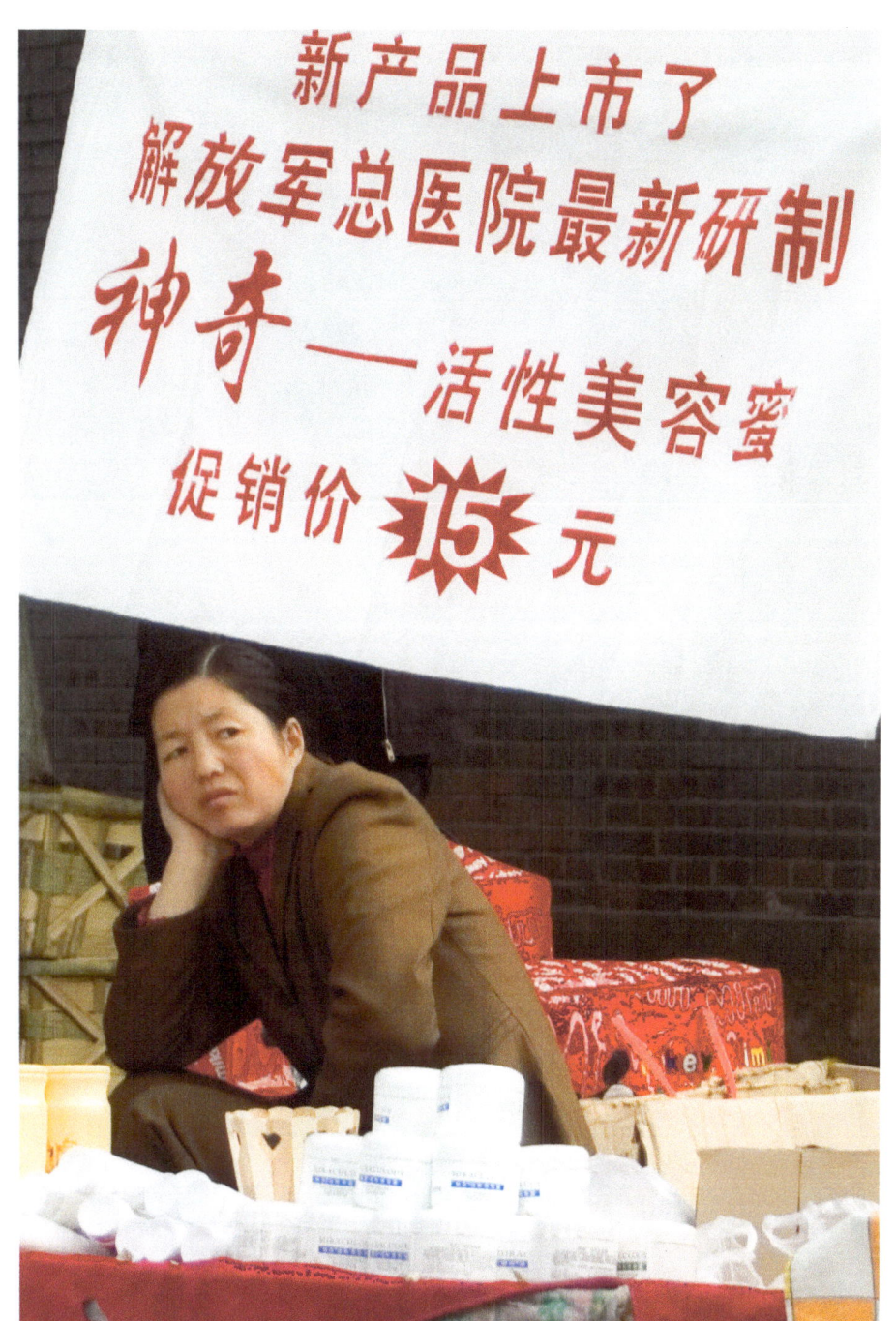

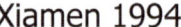
Xiamen 1994

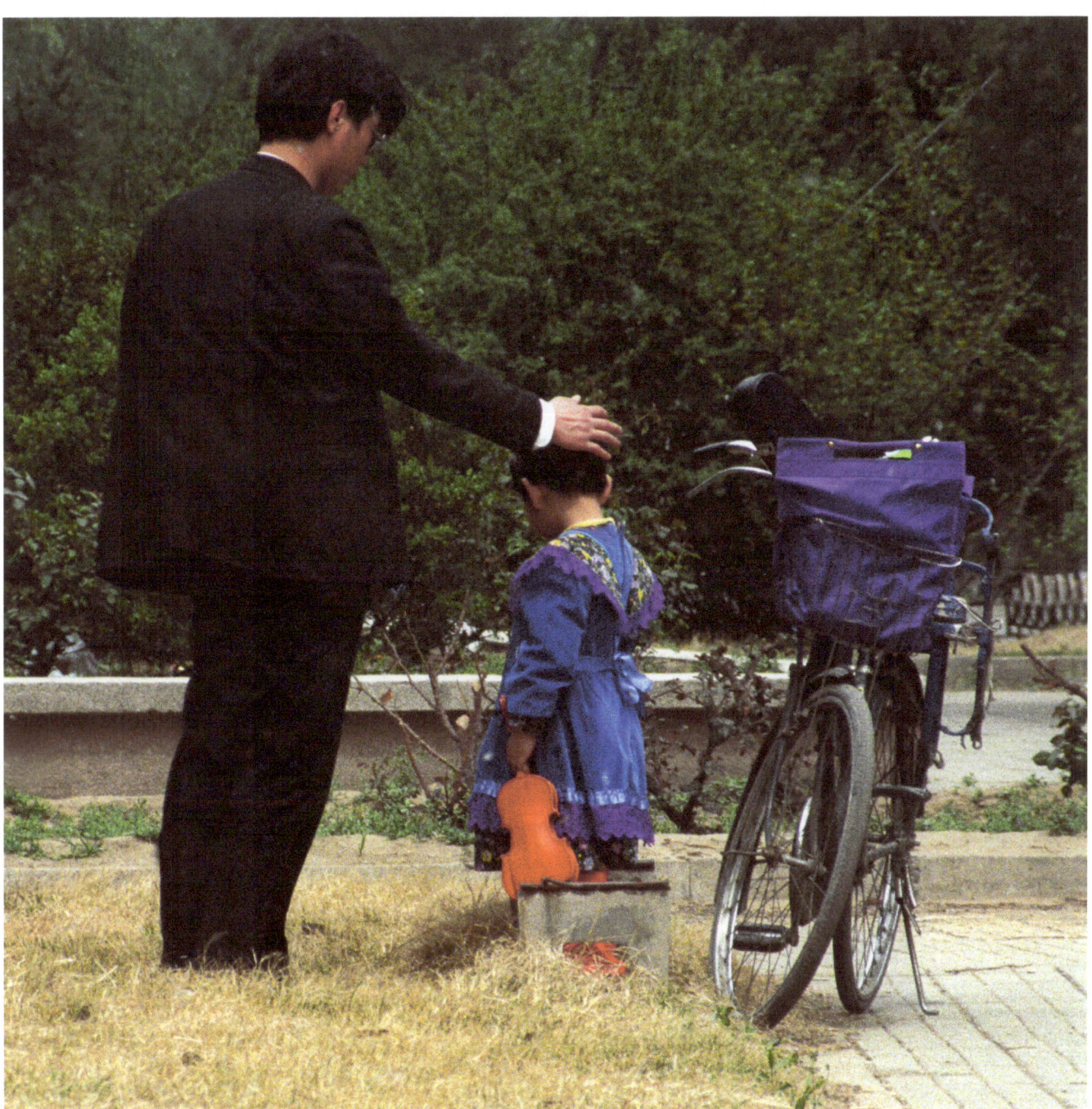

Beijing 1994

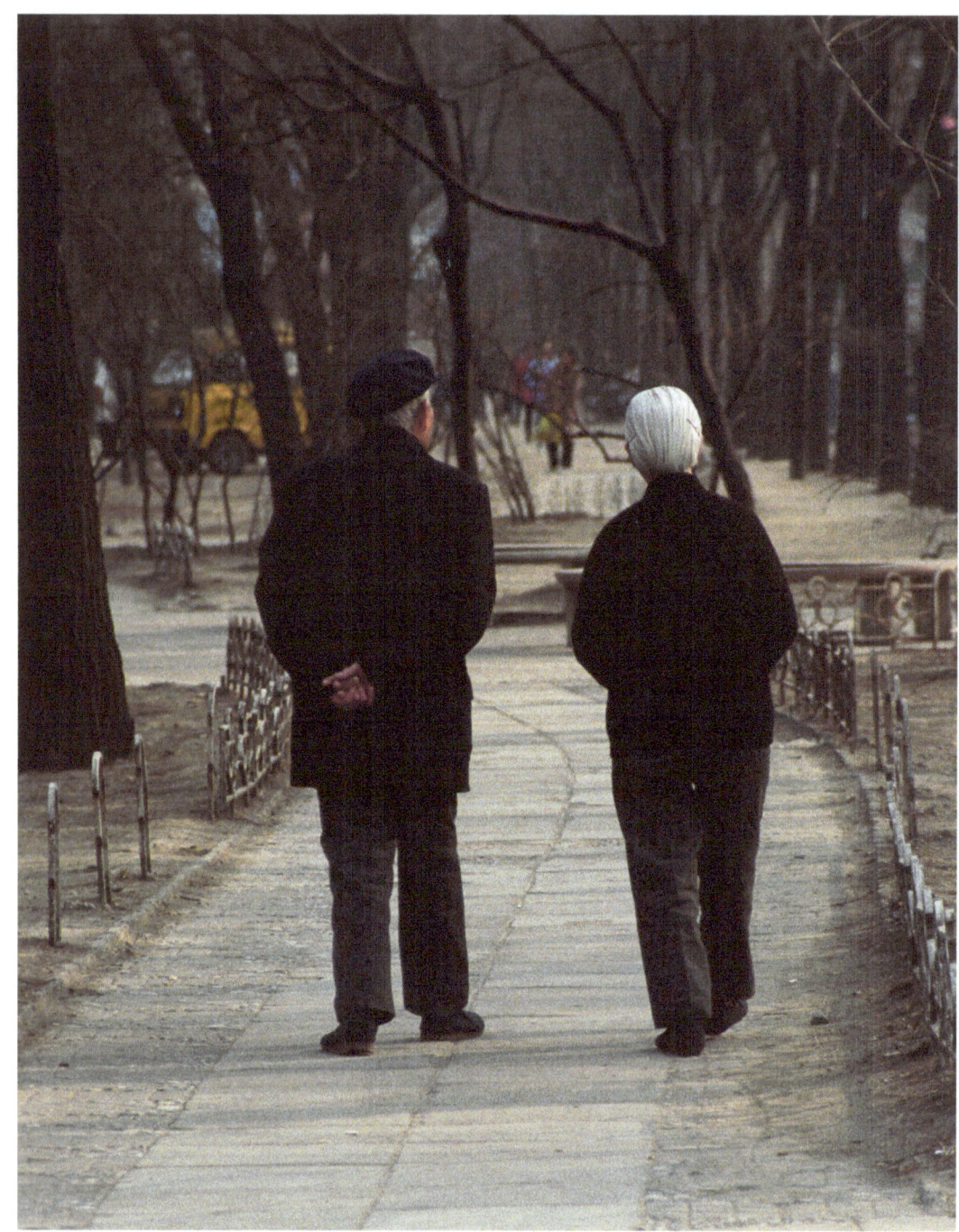

Beijing 1994

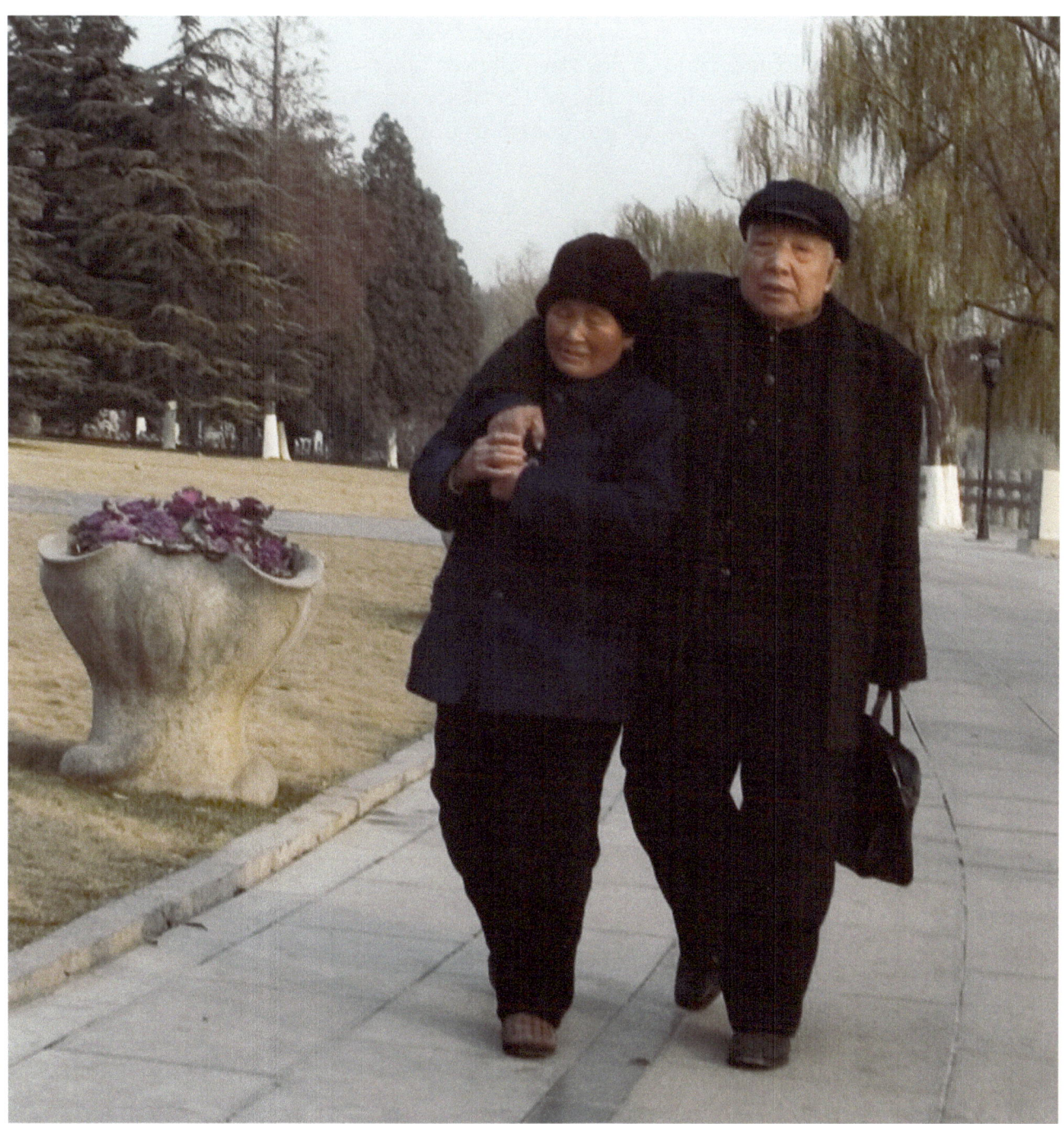

Jinan 2005

I have seen a lot of changes in China between 1994 and 2005 and I haven't even seen all of China. But the final two photos help summarize the changes. In 1994 you could see distance between an elderly couple; in 2005 an elderly couple walked arm in arm in public. That was a great leap forward.

Appreciation

I created a draft of this book under the tutelage of Sam Abell and Leah Bendavid-Val of *National Geographic*, and Mim Adkins, a graphic designer, at Santa Fe Workshops in Santa Fe, New Mexico. I thank them for their patience and guidance. As with other articles and books I've done, I'm always grateful for the stern editorial support of Sally Heffentreyer. I thank my wife, Paulette, for joining me on some of my trips to China and for maintaining her keen interest in China, which has supported my interests. Finally, my highest regard for the people of China. If it weren't for the people, I wouldn't have gone back to China so many times.

Additional titles

For adults:

Eye on Cuba at www.createspace.com

Wales Married to the Eye at www.blurb.com

Canyon de Chelley at www.lulu.com

Chianti from a Tuscan Villa at www.lulu.com

Cerro at www.blurb.com

For children:

The Bump on Lucy's Nose at www.lulu.com.

The Cottontails and the Jackrabbits at www.lulu.com.

Anita Amiga Explores Beijing at www.lulu.com.

www.ingramcontent.com/pod-product-compliance
Lightning Source LLC
Chambersburg PA
CBHW050750180526
45159CB00003B/1409